CONCORD FREE PUBLIC LIBRARY

3 4860 00 60 412

W9-AAW-131

759.5
Botticelli - Zeri

**FEDERICO ZERI** (Rome, 1921-1998), eminent art historian and critic, was vice-president of the National Council for Cultural and Environmental Treasures from 1993. Member of the Académie des Beaux-Arts in Paris, he was decorated with the Legion of Honor by the French government. Author of numerous artistic and literary publications; among the most well-known: *Pittura e controriforma*, the Catalogue of Italian Painters in the Metropolitan Museum of New York and the Walters Gallery of Baltimora, and the book *Confesso che ho sbagliato*.

## Work edited by FEDERICO ZERI

**Text**
based on the interviews between
FEDERICO ZERI AND MARCO DOLCETTA

This edition is published for North America in 2000 by NDE Publishing*

**Chief Editor of 2000 English Language Edition**
ELENA MAZOUR (*NDE Publishing**)

**English Translation**
SUSAN SCOTT

**Realization**
ULTREYA, MILAN

**Editing**
LAURA CHIARA COLOMBO, ULTREYA, MILAN

**Desktop Publishing**
ELISA GHIOTTO

ISBN 1-55321-014-X

### Illustration references

**Alinari Archives:** 2a, 5as, 18s-d, 23, 26s, 27, 38d, 44/III-IV-V-VIII, 45/XI.

**Alinari/Giraudon Archives:** 1, 2-3, 4, 5bs-d, 6-7, 7bs-d, 8, 9 as-d, 10, 10-11a-b, 11bs-d, 12a-cs-b, 13, 14s, 14-15, 20s, 30a, 32, 34-35, 37a, 44/XI, 45/V-VI-X, 47.

**Bridgeman/Alinari Archive:** 30-31, 35b, 36b, 43, 45/III-IX.

**Giraudon/Alinari Archives:** 9bs, 28b, 45/IV.

**Luisa Ricciarini Agency:** 2b,16, 17d, 19s-d, 20d, 21d, 22b, 24a, 24-25, 26d, 28a, 29, 31a, 32-33, 44/I-II-VI-VII-IX-X-XII, 45/I-II.

**RCS Libri Archive:** 22a, 24b, 35a, 36c, 37b, 38s, 39a-b, 45/VII-VIII-XII-XIII-XIV, 46.

**R.D.:** 6b, 7as, 11as-c, 12cd, 14ad-bd, 16a, 17as-bs, 21s, 36a, 40, 41, 42.

© 1998 RCS Libri S.p.A. - Milan, Italy
© 2000 NDE Canada Corp. for English language edition

All rights reserved. No part of this publication may be reproduced, stored in a retrieval system or transmitted in any form or by any means, electronic, mechanical, photocopying, recording or otherwise, without the prior written permission of the copyright owner.
The cover design for 2000 North American English language edition
is the exclusive property of NDE Canada Corp. with all rights reserved.

Printed and bound by Poligrafici Calderara S.p.A., Bologna, Italy

 a registered business style of NDE Canada Corp.
15-30 Wertheim Court, Richmond Hill, Ontario
L4B 1B9 Canada, tel. (905) 731-1288

*The captions of the paintings contained in this volume include, beyond just the title of the work, the dating and location. In the cases where this data is missing, we are dealing with works of uncertain dating, or whose current whereabouts are not known. The titles of the works of the artist to whom this volume is dedicated are in blue and those of other artists are in red.*

# BOTTICELLI
# THE ALLEGORY OF SPRING

Nature, such an important presence in Renaissance art, is celebrated in THE ALLEGORY OF SPRING with a profusion of light and color. This painting is among the most mysterious in all the history of art, and scholars have long tried to unlock its arcane secrets. Even after the

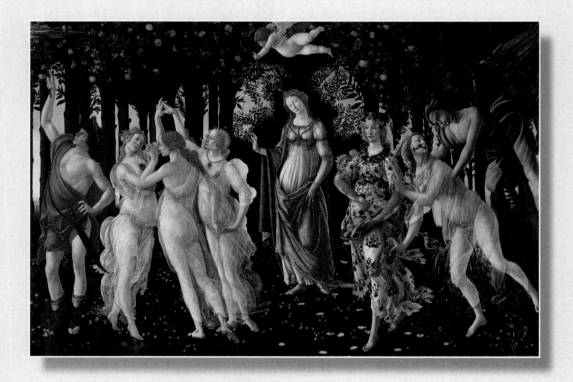

various personages have been identified, the overall meaning still remains uncertain. The expression of a culture imbued with symbolic and allegorical allusions like that of the fifteenth century, the painting lends itself to the most varied hypotheses for interpretation.

# A GARDEN OF DELIGHTS FOR CULTURE

### THE ALLEGORY OF SPRING
*c.1482*

● Florence, Uffizi (tempera on panel, 314 x 203 cm)

● This title, by which the work has been known for some time, is based on Vasari's description: "Venus, whom the Graces are covering with flowers, as a symbol of spring". The subject of this refined, cerebral painting is difficult to interpret. Scholars have struggled for decades to elaborate theories to explain every detail of the picture, but no one has yet succeeded in revealing its meaning completely.

● It is not even certain exactly who commissioned the work, but the person who ordered the painting from Alessandro Filipepi, called Sandro Botticelli, had to have been a member of the rich and powerful Medici family. The presence of *The Allegory of Spring* in their villa at Castello has in the past led historians to conclude that the patron was Lorenzo di Pierfrancesco, the cousin of Lorenzo the Magnificent, and that the work was painted before Botticelli went to Rome. Now, the tendency is to think that *The Allegory of Spring* was commissioned by Lorenzo the Magnificent for the wedding of his cousin Lorenzo to Semiramide Appiani, and thus that it was painted around 1482.

● In this case, the recently offered interpretation, which holds that a Latin text by Martianus Capella entitled *De nuptiis Mercurii et Philologiae* contains a description of the subject represented here, is in line with the occasion which seems to have generated the painting. This late Roman text was known in the Middle Ages and Renaissance, as it was studied in schools of rhetoric.

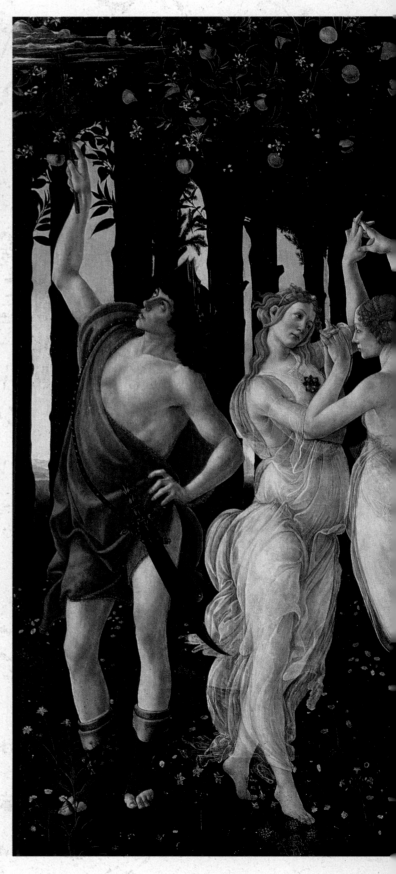

◆ THE PATRON AND THE ARTIST At left is Botticelli's presumed self-portrait, as it appears in his *Adoration of the Magi* in the Uffizi. Above, *Portrait of Lorenzo the Magnificent* by **Giorgio Vasari** (Florence, Uffizi).

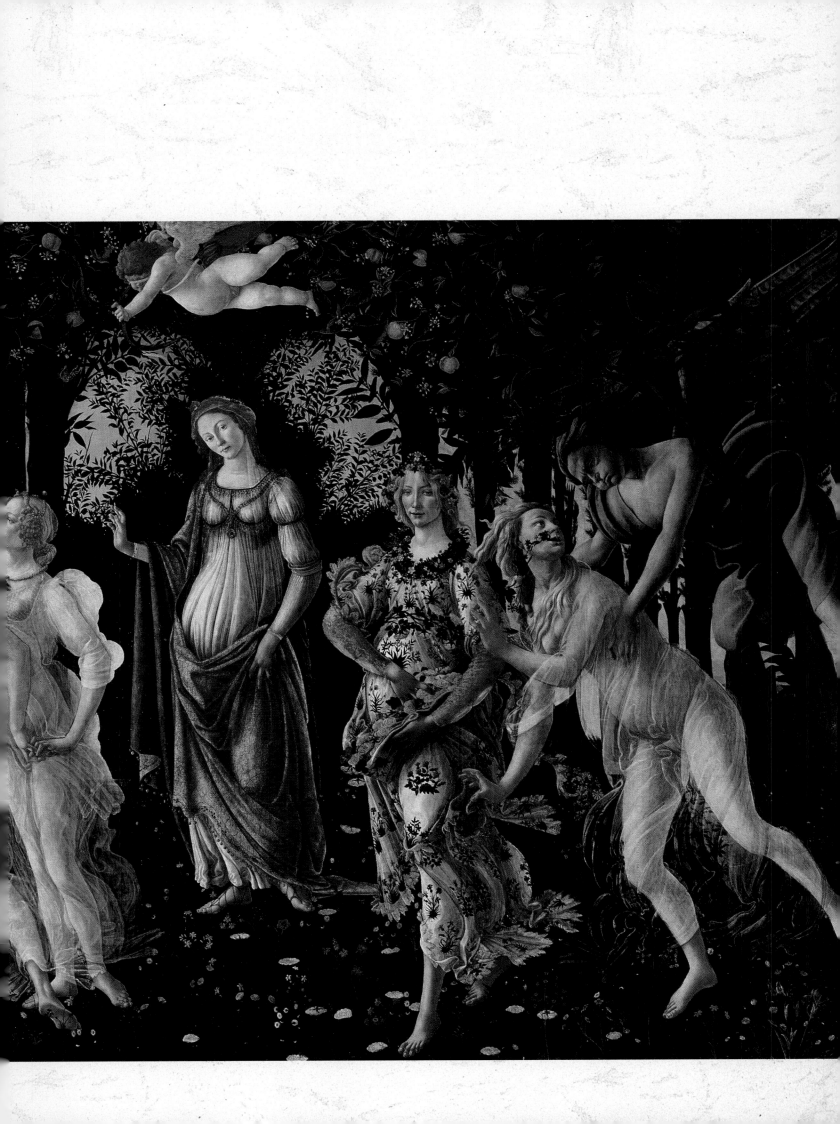

# A HARMONY OF SINGLE FIGURES

The search for the beautiful as a value in itself, that is produced by art, places Botticelli on a different plane from his contemporaries Leonardo, Michelangelo, and Raphael, who considered art to be a means of investigation and knowledge of nature and history. Botticelli – in this sense he belongs more to the fifteenth than the sixteenth century – aims in his work at elaborating a philosophy which unites art, thought, and poetry. This is the source of the real difficulty in interpreting some of his works, as is the case with *The Allegory of Spring*.

Next to her is another female figure (the goddess Flora) wearing a flowered dress and carrying flowers, which she scatters as she walks. In the center a standing figure makes a gesture of benediction: she is the goddess Venus who, with her head tilted slightly to one side, looks out of the picture, with Cupid flying above her about to shoot an arrow at one of the dancers in the trio below. On the left, the dancing group of women wearing veiled garments is easily identified as the three Graces. On the far left Mercury, covered only by a red chlamys, lifts his ca-

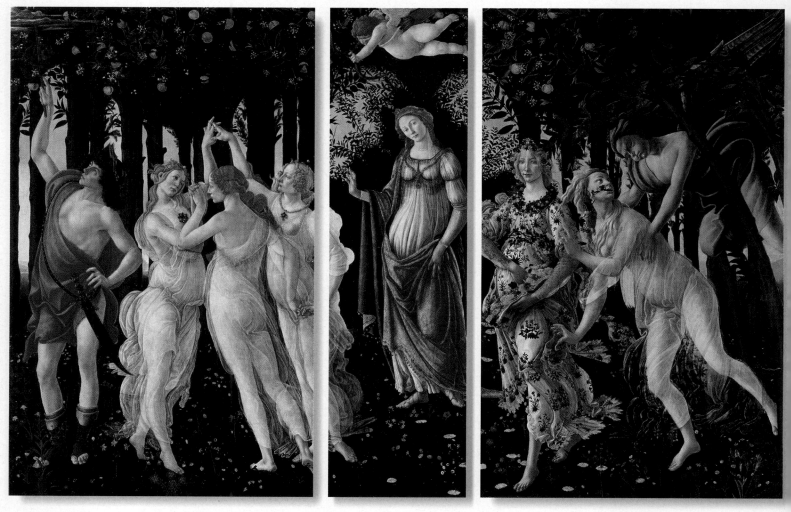

● A first look at the panel – which should be read from right to left – allows us to approach the nine figures present in the scene, who appear in perfect harmony but not connected with each other. Zephyrus, the wind of spring, grabs a nude woman clad only in thin veils – the nymph Chloris – and weds her: flowers stream out of the mouth of the impregnated goddess.

duceus toward the top of the trees to dispel the clouds.
● The scene takes place in a thick woods; a blue-gray light filters through from the back, allowing us to glimpse a veiled panorama on the far edge of the horizon. A meadow embroidered with a profusion of flowers forms the soft carpet on which the figures move.

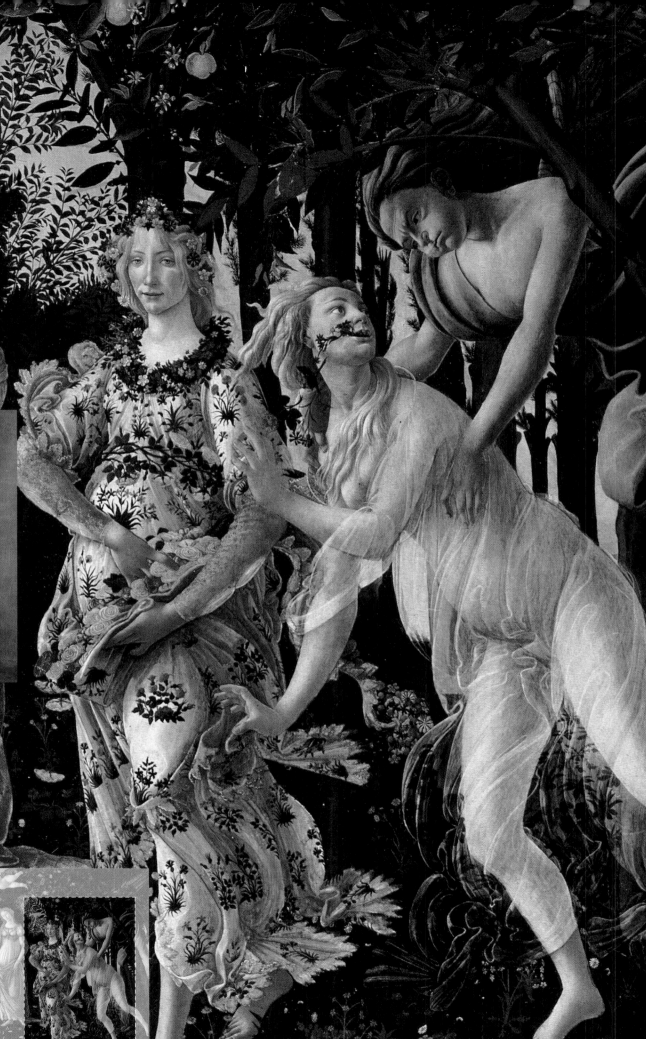

◆ THE TRANSMUTATION
The wood nymph
Chloris, seized and
impregnated by the
west wind Zephyrus,
the wind of spring,
is transformed into
a goddess, Flora,
the bearer of spring.
In a passage from
Ovid's *Fasti*, Chloris
states: "I was Chloris,
who am now called
Flora." Given the
learned and refined
sphere in which
Botticelli moved, it is
highly probable that this
is the literary source for
the representation.

◆ THE ROMAN MODEL
The Roman statue
of *Pomona* (Florence,
Uffizi) is a possible
model of reference for
the figure of Flora.
The autumn fruit,
gathered in a fold
of her dress,
is here substituted
by spring flowers.

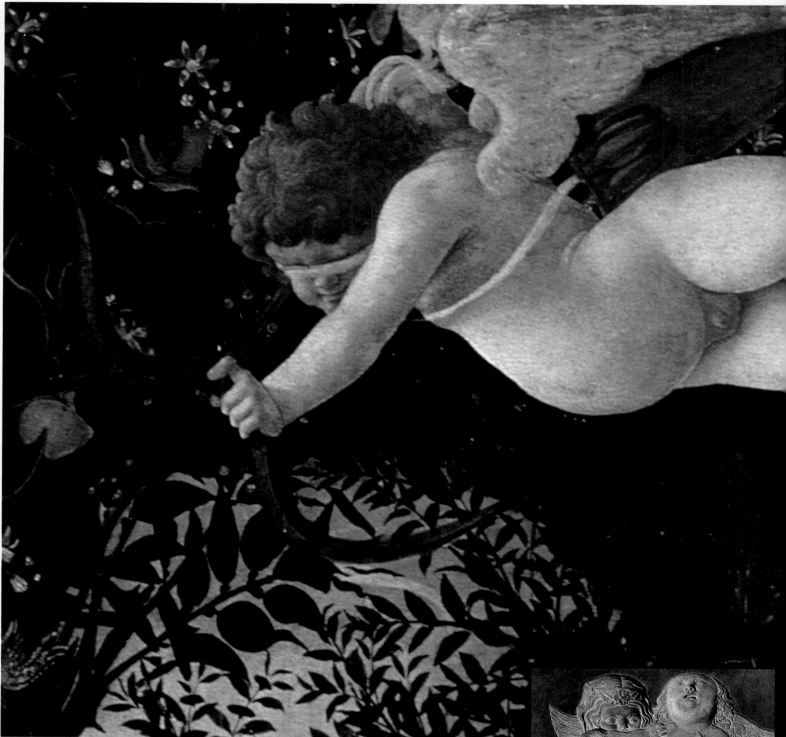

♦ **THE ANGELIC SHARPSHOOTER**
Cupid flies above Venus's head, blindfolded and ready to shoot his burning arrow toward the central figure of the Graces: Chastity. The chubby little god of love – the son of Aphrodite and Hermes, according to one of the most frequently cited genealogies in the literary sources – thus puts the figure of Venus in relationship with all the figures on the left side of the painting: Mercury and the Graces. From an exclusively stylistic point of view, a precedent for Botticelli's Cupid can be found in the *Angels Musicians* (1447-54) in the Tempio Malatestiano in Rimini, the work of the Florentine sculptor Agostino di Duccio, of which a section is shown at right. The linear rhythm which empties the shapes of their volume is the element which more than any other unites the two works.

◆ A REGAL PROGRESS
The posture, the gesture
of greeting, the drapery,
and the architecture
surrounding the figure,
above, of *Venus Victrix*
(London, British
Museum) are the same
as for the Venus in
Botticelli's picture.
During his time, this
Roman relief, the statue
of Pomona, and a lost
relief showing the
Graces were present,
one next to the other,
in the Roman collection
of the Del Bufalo family,
offering a sort of curious
foreshadowing of
*The Allegory of Spring*. The
canopy around the *Venus
Victrix* is maintained and
transformed
by the artist into
an architecture
of vegetation more
fitting with the natural
environment chosen as
setting for the scene.

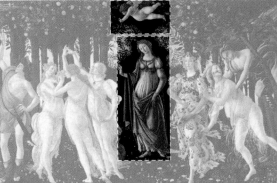

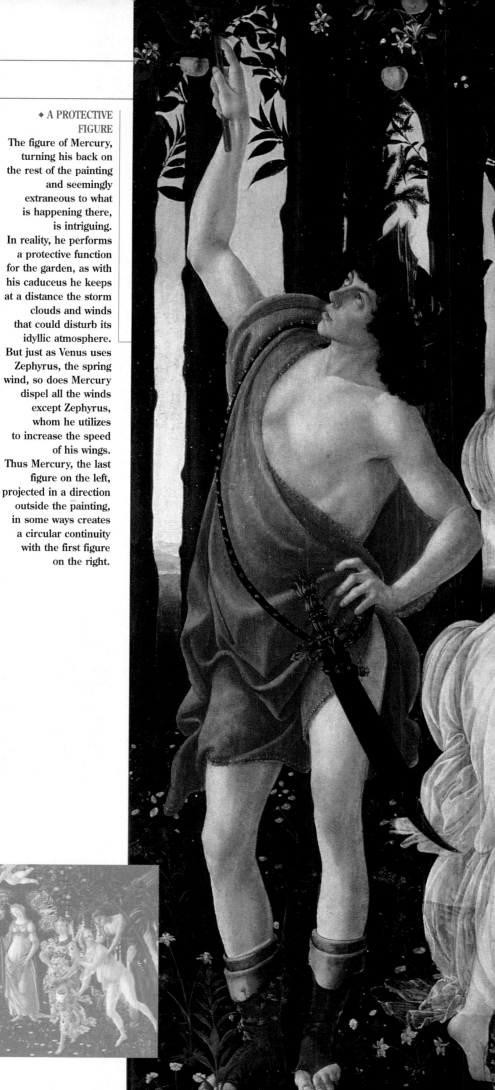

The figure of Mercury,
turning his back on
the rest of the painting
and seemingly
extraneous to what
is happening there,
is intriguing.
In reality, he performs
a protective function
for the garden, as with
his caduceus he keeps
at a distance the storm
clouds and winds
that could disturb its
idyllic atmosphere.
But just as Venus uses
Zephyrus, the spring
wind, so does Mercury
dispel all the winds
except Zephyrus,
whom he utilizes
to increase the speed
of his wings.
Thus Mercury, the last
figure on the left,
projected in a direction
outside the painting,
in some ways creates
a circular continuity
with the first figure
on the right.

◆ THE MODEL
FOR MERCURY
Placed at one time
in the courtyard
of Palazzo Medici,
the bronze *David*
by Donatello (c. 1430,
Florence, Museo del
Bargello) constitutes
with its pose, beret,
and winged boots
the probable model
for the Mercury shown
here in detail.

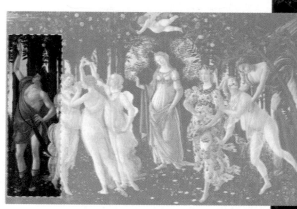

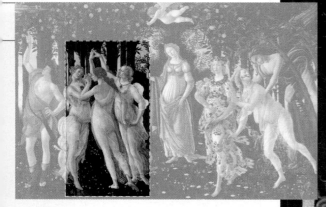

♦ RAPHAEL
*The Three Graces*
(1504-05, Chantilly,
Musée Condé).
The harmony
of the dance
of Botticelli's
Graces finds
a subtle counterpoint
in the studied
balance
of the rhythms
of the bodies
and movements
of Raphael's Graces.
With their ochre-
colored flesh
they present
themselves
as solidly constructed
and perfectly balanced
in proportion
and movement,
in a geometric
structure typical
of Renaissance art,
which yet manages
to suggest the sense
of an intertwining
of the three states
of love:
chastity, sensuality,
and beauty.

♦ THREE
SPREADERS
OF JOY
A slow and melodious
rhythm marks
the dance of the
Graces, divine
creatures covered by
transparent veils,
symbolizing love that
is given, received,
and returned and
defining an intimate
relationship between
Voluptuousness,
represented by the
Grace on the left,
Chastity, by the one
in the center, and
Beauty, on the right.
The harmonious triad,
accompanied
by Mercury, enters
into relationship,
through the figure of
Venus, of whose train
they are a part, with
the other triad made
up of Zephyrus,
Chloris, and Flora.
Together they represent
variations in the
dialectic of love.

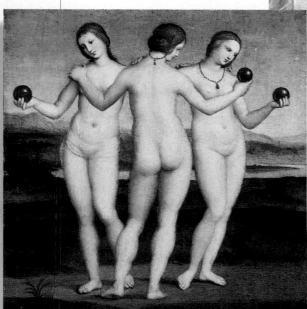

# THE HIDDEN MEANING

*T*he *Allegory of Spring* reveals Botticelli's profound intellectual virtuosity and incessant speculation, which loves to use the literary game of allegory to free his forms of any connection whatever with a definable, recognizable space and time. The cancellation of depth of space and the multiplication of rhythmic cadences, resonating like the words of poetry, lead the artist to a dissolution of plastic form and perspectival space in favor of linearism and two-dimensionality.

● Turning the images into allegory requires a constant recourse to the use of symbolic codes, both in terms of the gestures and placement of the figures in space, and to refer to hidden meanings of some secondary attributes of the elements represented.

● Thus we find ourselves in the position of having to interpret a large number of symbols whose specific use here could change or even overturn the literal meaning which emerges on a preliminary examination of the picture.

● The Garden of the Hesperides, sacred to Venus, which seems to provide the setting for *The Allegory of Spring*, changes its meaning because of the presence of laurel trees, recalling the name of Lorenzo (*Laurus=Laur*(enti)*us*), who commissioned the painting. Besides, all the members of the Medici family who bore the name Lorenzo used the laurel in their arms, so by extension it can symbolize the entire family. In this way, the extraordinarily idyllic relationship between man and nature seen in the painting could come to symbolize an idyll between *humanitas* and the Medici.

● The elements present, therefore, do not represent themselves alone but set up resonances referring to other things. The jewels worn by the Graces and Venus, like the flowers, establish a symbolic relationship between the persons and nature and at the same time say that their eyes sparkle like jewels, their lips have the freshness of roses, their skin is as translucent as pearls.

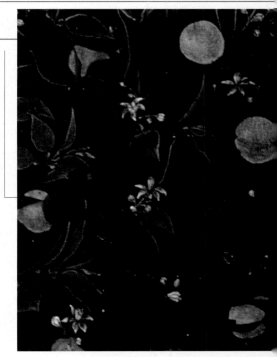

◆ THE APPLES OF THE GARDEN OF THE HESPERIDES
Trees laden with oranges, another attribute of Venus, form a natural roof of vegetation over the figures' heads. The fruits recall the apples of the Hesperides which, once tasted, bring love and fertility, and represent a clear reference to the coat of arms of the Medici family which, like the apples, brings about prosperity and harmony among men.

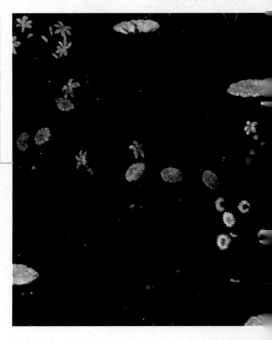

◆ THE FLOWERY MEADOW
The plane on which the eight characters stand is a soft carpet of flowers and grass, in which botanists have recognized dozens of different species. Attention to vegetable forms is typical of the naturalism of the Flemish painters, who were well known in the Florentine art world. At right, a detail from the *Portinari Altarpiece* (c. 1478, Florence, Uffizi) by Hugo van der Goes.

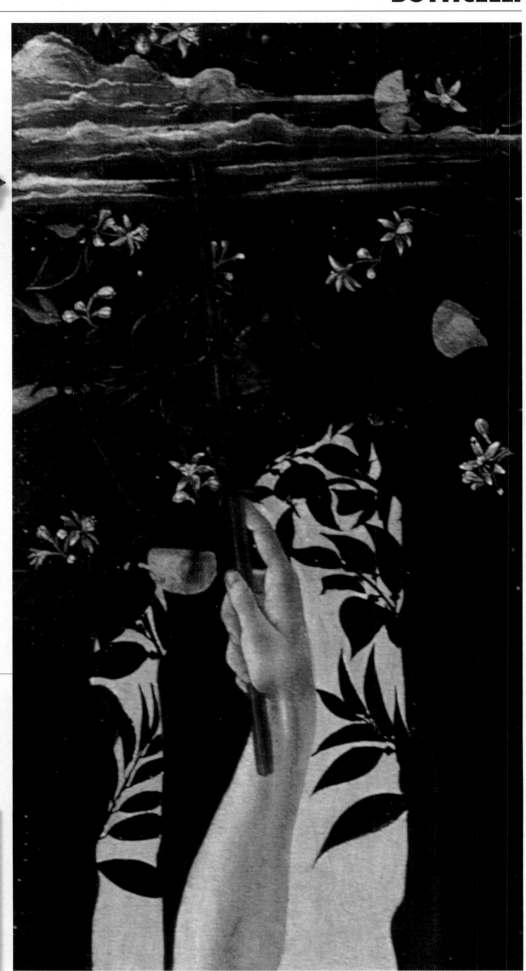

◆ **MASTER
OF THE TAROT CARDS**
*Mercury*
(c. 1465).
This Mercury,
very well known
in Florentine circles,
is another
of the possible models
used by Botticelli.

◆ **IL CADUCEUS**
The symbol of peace
and prosperity
in heraldry,
the caduceus
is made up of a rod
with two snakes
at its top
intertwining
symmetrically.
Attribute of Mercury, as
he is the messenger
of the gods, it is used
by him to keep
storms away, whether
meteorological or
metaphorically referring
to the difficulties
the Medici family might
find along its path.

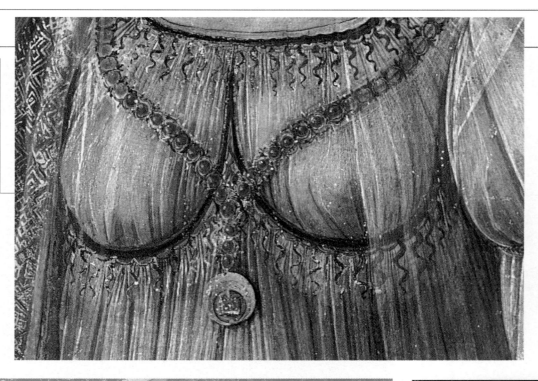

**◆ A JEWEL AMONG THE VEILS**
The pendant hanging on Venus's breast contains the two main attributes with which the goddess of love is usually represented: the pearls produced by the oyster shell, connecting the goddess with the sea which spawned her, and the flame of the fire of love, captured by the ruby set into the pendant.

**◆ LEONARDO DA VINCI**
*Portrait of Ginevra Benci* (c. 1474, Washington, National Gallery of Art). In Leonardo's famous painting, the juniper tree in the background suggests and evokes the name of the sitter. In this same way, the myrtle woods behind Venus identifies immediately the goddess of love and beauty through the presence of the tree sacred to her.

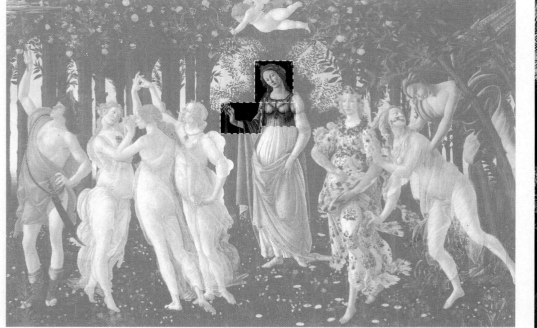

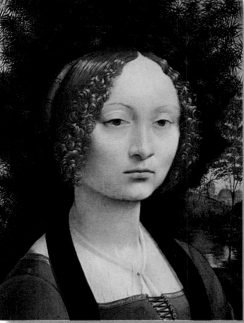

**◆ INVITATION AND GREETING**
According to the code of social behavior of the time, the gesture that Venus makes with her hand has the value of an invitation and a welcome: a gesture at the same time of regal hospitality and of urging the viewer to enter into the kingdom of beauty. The aspect of Venus emphasized here is her morally most noble one, her sublime *humanitas*.

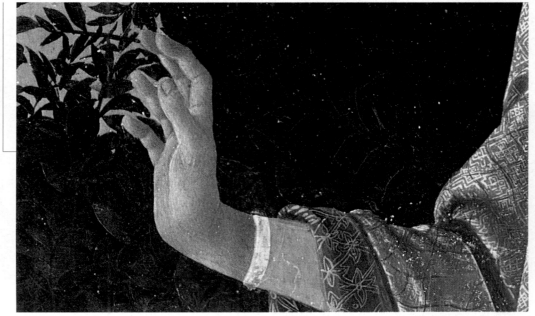

**◆ A PLAY OF GLANCES**
The viewer's pleasure at seeing this painting is due in large part to the unreal atmosphere of a distant and rarefied world, heightened by the undefined physiognomy of the protagonist, who nonetheless seems to be looking directly at the spectator. But it is a Sibylline glance, that looks without seeing and seems instead to be absorbed in her own melancholy inner reflections.

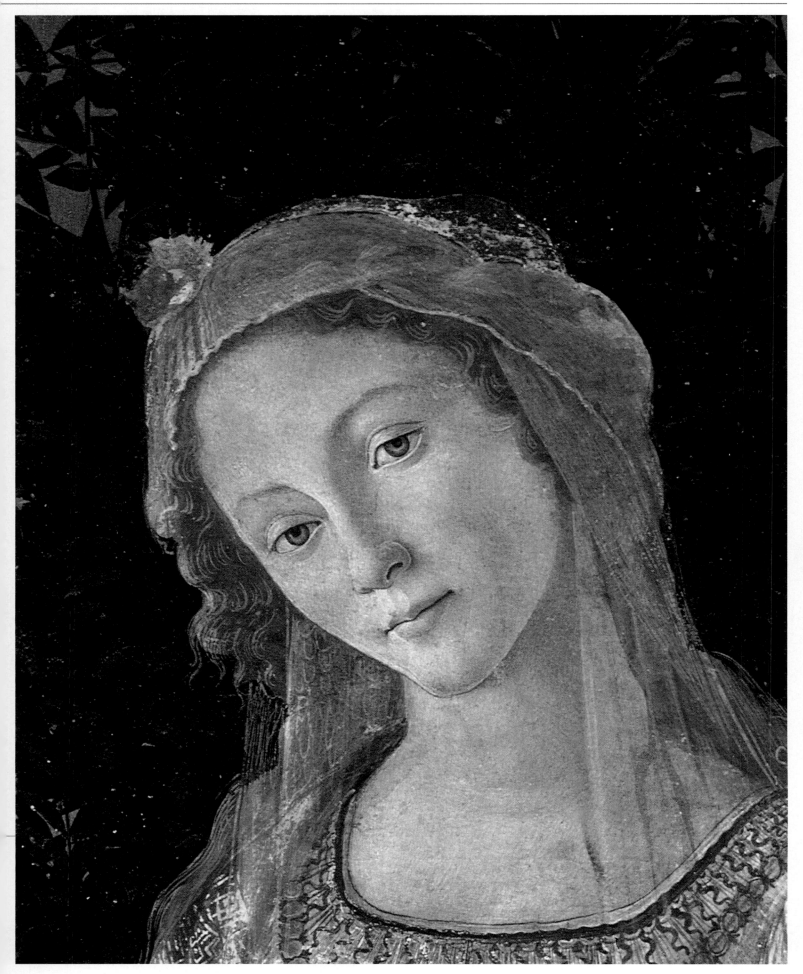

# THE LINES

The painter has succeeded in imbuing the painting with a sublime elegance and an extraordinary chromatic quality, using tempera applied onto a prepared wooden panel. Here and there touches of an oily substance – revealed by the operation of restoration and cleaning of the painting in 1983 – infuse brilliance and transparency to the colors.

● But, in Botticelli's works, shapes are not created so much by color as by the movement of the line, which tends to make matter practically impalpable and to give it the consistency of light. And it is a very special light, one that renders the figures diaphanous, wraithlike, light and floating, their contour lines dissolving into nothingness.

● Line also fulfills the function of marking off the measure of time and thus revealing its rhythm. The entire composition follows a

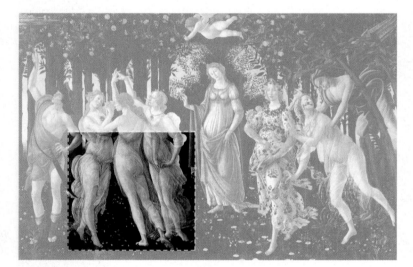

metrical, rhythmic cadence like that of Politian's "Stanzas," and the central figure represents the "caesura," the pause which allows one to take a breath and pulls together the musicality of the verse.

● The succession in the background at irregular intervals of the tree trunks, now large, now smaller, underlines the melodic cadence of the whole, which unfolds with great refinement and lightness, like the music composed to express the sensibility of the time.

● This is the first time in the figurative arts that we see figures defined not by a single contour line, but by numerous lines, of which it is impossible to say exactly which one, more than any of the others, suggests the edge of the figure. Even the movement – in the absence of a backdrop to help develop the action – is created by the flow of the line. In the group of the Graces, in effect, it is the floating veils which create the figures' relationship with space and give the illusion of movement.

◆ LINES AND TRANSPARENCES Above and below are **Agostino di Duccio's** figures of *An Angel Holding a Curtain* and *The Moon*, in the Tempio Malatestiano in Rimini. Both compositions are marked by a melodious linearism, which we find again in the fluid fullness of the veils of the Graces, right. Notice how the movement is merely suggested by the floating of the diaphanous, transparent veils and by the synchronized, rhythmic harmony of the lines of their bodies.

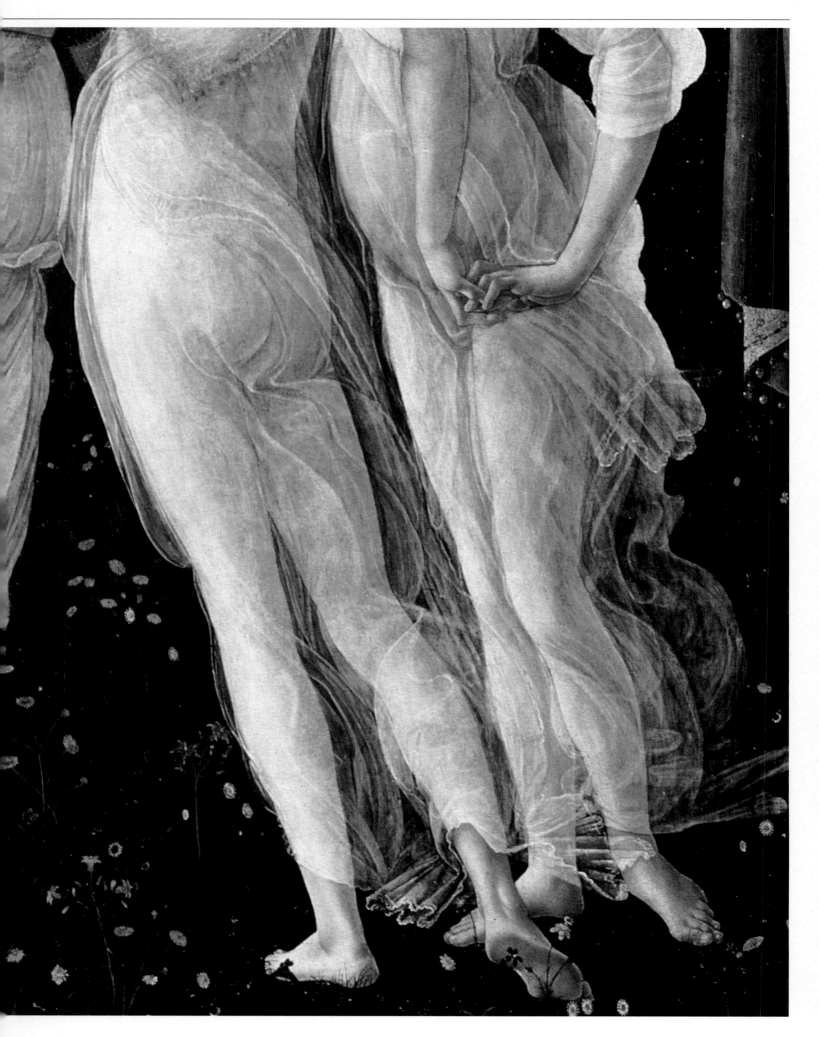

# UNIVERSAL HARMONY

Botticelli received his artistic training first in a goldsmith's workshop and then in the shops of Filippo Lippi, Andrea Verrocchio, and the brothers Antonio and Piero del Pollaiolo. Selecting elements from the figurative language of each of his teachers, he created his own individual style, based on the constructive potentialities of line and a love for refined details.

● His cultivated, but at the same time pleasing and refined language responded to Florentine society's taste, just as the pope appreciated his capacity to translate stories into images, so much so that he commissioned him to paint frescoes in the Sistine Chapel.

● The refined intellectual atmosphere breathed at the Medici court left a deep impression on the art of Sandro Botticelli, who became the figurative spokesman for the Neoplatonic theories, being expressed by the most brilliant minds of an era in which philosophy, art, and poetry converged as never before and never again.

● The harmonic balance that fostered the construction of this climate came apart, and the painter's sensitive soul was quick to absorb the profound spiritual unease that found expression in the preachings of the Dominican friar Gerolamo Savonarola. After the friar's death, Botticelli abandoned all artistic research, while other artists – Leonardo, Michelangelo, Raphael – were already active in the city, introducing a very different kind of taste. Just a short time after his death in 1510, Botticelli was already forgotten.

◆ **THE TRIALS OF MOSES** (1481-82, Rome, Palazzi Vaticani, Sistine Chapel). The story of Moses is broken up into episodes, represented in the same space and separated by elements of the landscape, following a custom still belonging to the Middle Ages.

◆ **FILIPPINO LIPPI** *The Crucifixion of St Peter* (1481-83, Florence, Church of the Carmine, Brancacci Chapel). The detail shown here is thought to be a portrait of Botticelli painted by his disciple.

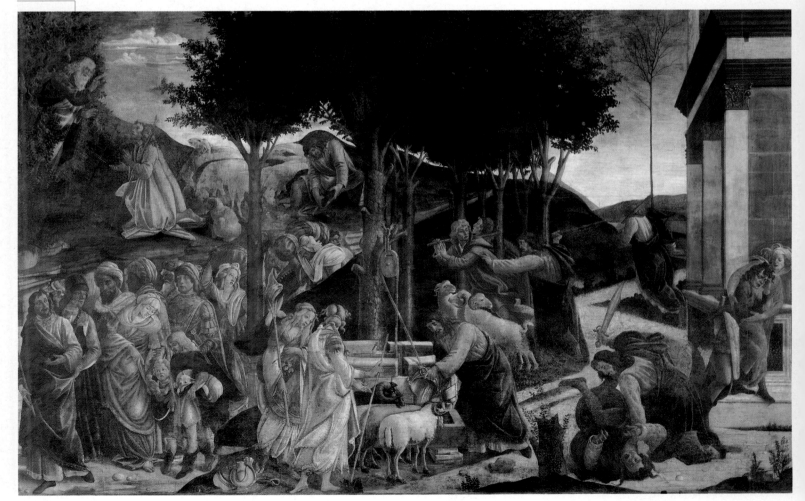

♦ BUST OF LORENZO
THE MAGNIFICENT
(Florence, Uffizi).

♦ ANTONIO AND PIERO
DEL POLLAIOLO
*Tobias and the Angel*
(c. 1478, Turin,
Galleria Sabauda).
The Pollaiolo brothers'
interest in
the dynamic structure
of the human body
is such that
it is no longer seen
as perfect form,
but as energy.

♦ GIOVANNI
DELLE CORNIOLE
*Gerolamo Savonarola*
(1498-1516, Florence,
Museo degli Argenti,
engraved cornelian).
The Dominican friar
had a great following
in Florence, where he
preached against
the luxury of the
Medici court and
the corrupt politics of
the papacy and urged
a purification of society.

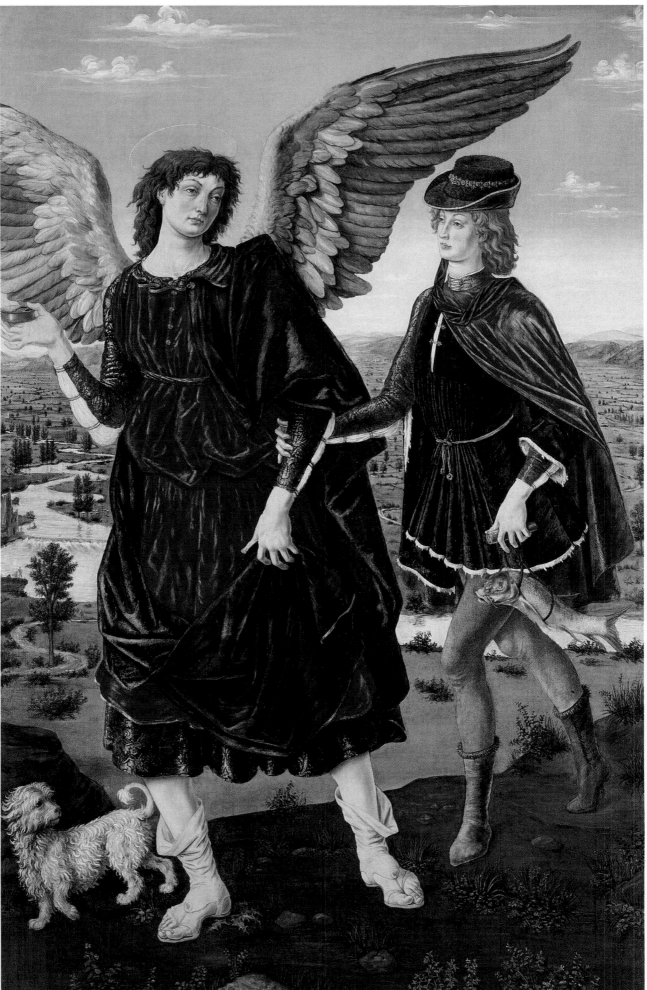

# THE APPROACH TO A LINEAR DYNAMISM

The artist's earliest work was as a goldsmith, for which he was nicknamed "Botticelli," which probably derives from "battigello" (gold-beater). His older brother Antonio was already active in the craft.

● But Botticelli very early manifested his desire to enter a real art workshop, and his father complied with this request by sending him in 1464 to Prato as an apprentice to Filippo Lippi, where he stayed three years. Here he learned from the master the rules of perspective and attention to detail, clearly derived from Flemish painting. A series of Madonnas shows his progressive detachment from Lippi and growing autonomy of expression.

● From 1467 to 1470 the young painter,

● THE DISCOVERY OF THE BODY OF HOLOFERNES (1472, Florence, Uffizi). This Bible story was a favorite subject during the fifteenth century, and Botticelli himself took it up again in a small panel of 1495.

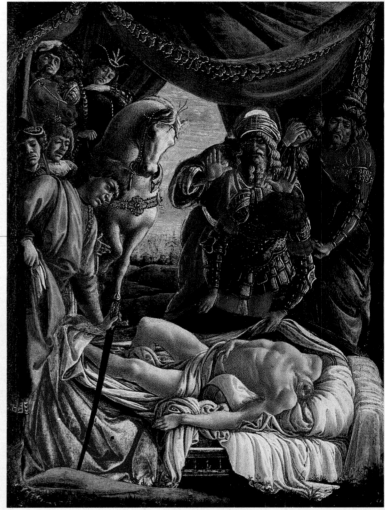

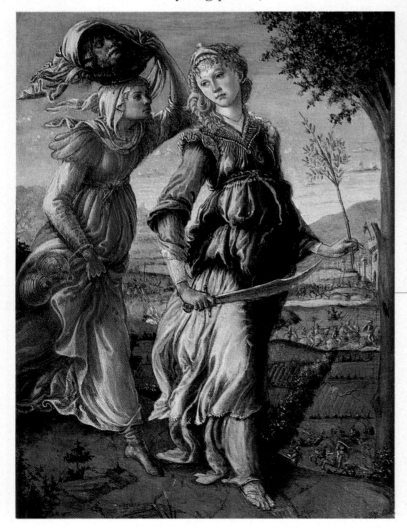

● JUDITH'S RETURN TO BETHULIA (1470-72, Florence, Uffizi). This panel together with *The Discovery of the Body of Holofernes* forms a diptych. The influence of Botticelli's teachers is readily apparent.

who lived in Florence on the Via Larga, frequented the workshop of Verrocchio, where Leonardo da Vinci was also studying. Here he learned, how to render volume, how to give figures three-dimensionality and place them in space. But just as important was his contact with the Pollaiolo brothers, from whom he learned linear dynamism.

● In 1470 he was awarded his first public commission: *Fortitude*. The panel is part of a cycle commissioned from Piero del Pollaiolo. Piero's delay in producing the paintings led to the assignment of Botticelli to make two of the panels; he actually only painted one because of Piero's protests. In 1472, by now the head of his own shop, he enrolled in the Compagnia di San Luca.

◆ FORTITUDE (1470, Florence, Uffizi). Commissioned by the judges of the Tribunale della Mercanzia, this was intended as part of a series of *Virtues* already begun the year before by Piero del Pollaiolo.

The powerfully modeled figure is emphasized by the red mantle in which she is wrapped and shows still the strong mark of his master's teachings. Botticelli takes advantage of his experience as a goldsmith in his rendering of the gilt, decorations, and metals. This is his first important public commission which makes him visible beyond his immediate circle of friends.

◆ PIERO DEL POLLAIOLO *Temperance* (1469, Florence, Uffizi). The panel was part of a series of the seven theological and cardinal virtues (Faith, Hope, Charity, Fortitude, Justice, Prudence, and Temperance) destined to decorate the hall where the Sei della Mercanzia met.

♦ FILIPPO LIPPI
*The Virgin and Child*
(1465, Florence, Uffizi).
Botticelli's first teacher
was a friar
in the convent
of the Carmine.
He established
a relationship
with Lucrezia Buti,
who was the mother of
his son Filippino Lippi;
Filippino would later
become Botticelli's
most important pupil.
Botticelli learned from
Lippi the tender
portrayal of affection
which we find in all
his early devotional
pictures.

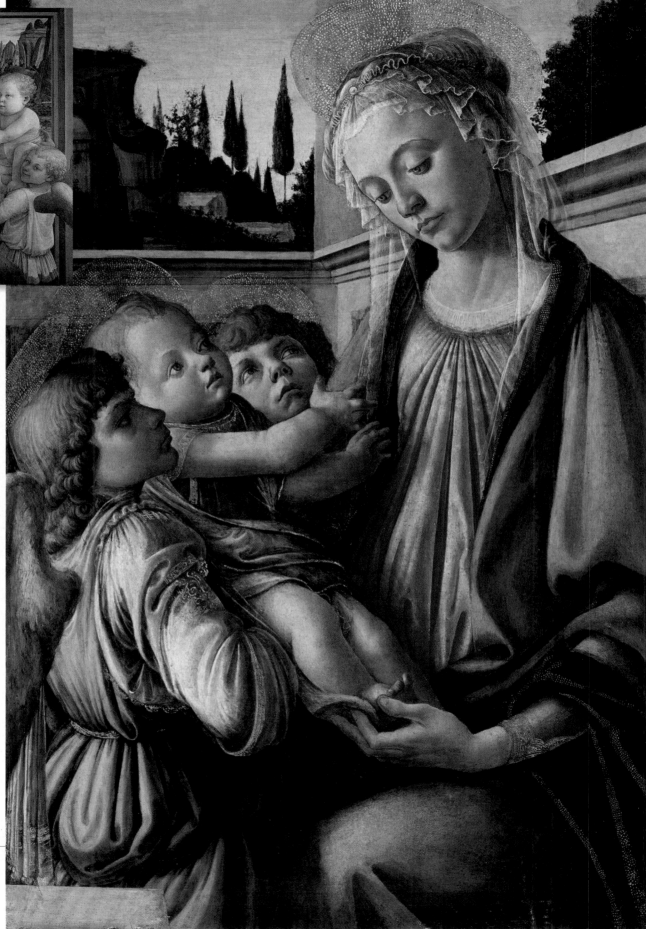

♦ THE VIRGIN
AND CHILD
WITH TWO ANGELS
(1469, Naples, Museo
di Capodimonte).
The affectionate
tenderness of Lippi's
Madonnas is united
here with a study of
volume which derives
from Botticelli's
apprenticeship in
Verrocchio's workshop.

◆ THE VIRGIN
AND CHILD
SURROUNDED
BY ANGELS
(c. 1470,
Florence, Uffizi).
This representation
reproposes the archaic
motif of the Virgin
enthroned, reworked
through a careful
graduation of the
volumes. Golden rays
frame the figure;
superimposed on them
is a frieze of cherubs'
heads. The virgin
is seated frontally,
with a slight turn
of her head slightly
to the right which lends
a strong plastic quality
to the figure.

◆ ANDREA
DEL VERROCCHIO
*The Virgin of the Rose-bush*
(c. 1470, Florence,
Uffizi). Verrocchio
taught Botticelli how
to create the spatial
relationship between
figures using modeling
and light.
His workshop was
full of students
and guaranteed a well-
rounded preparation
in the fields of
sculpture, painting,
and goldsmith work.

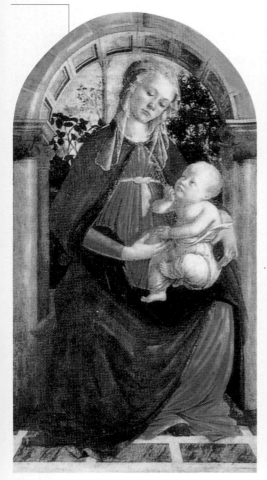

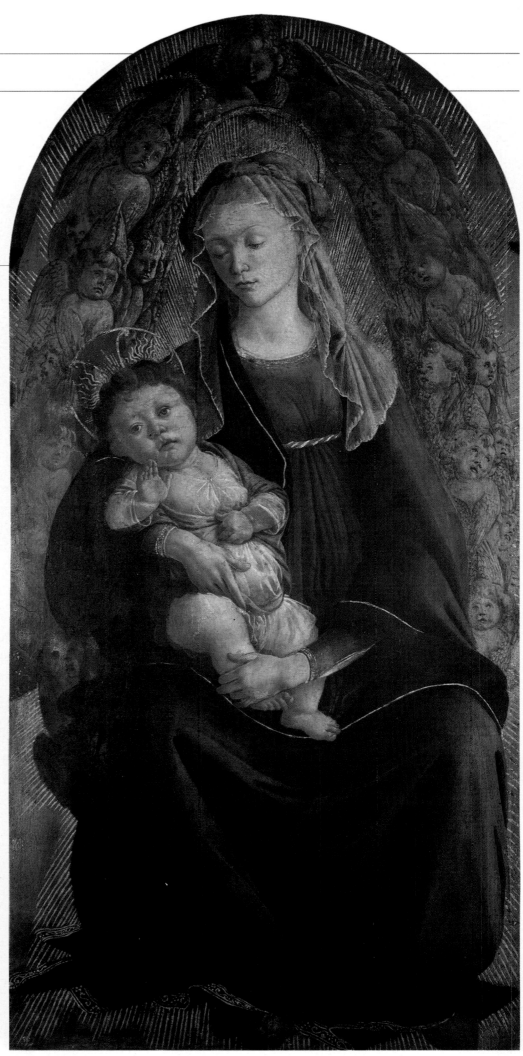

# SUBLIME BEAUTY

Expression of an urban elite, Renaissance culture is the patrimony of small circles; it replaced the old hierarchy, founded on the values of religion and the nobility, with a new one based on the values of the art of government, of knowledge, of taste.

● This aristocratic character helps explain the rapid spread of Renaissance culture not only in the sphere of the upper middle class, but also in the princely courts and the highest levels of the clergy. And it helps to understand the explosion of patronage, which lies at the base of almost all the great enterprises of the Renaissance.

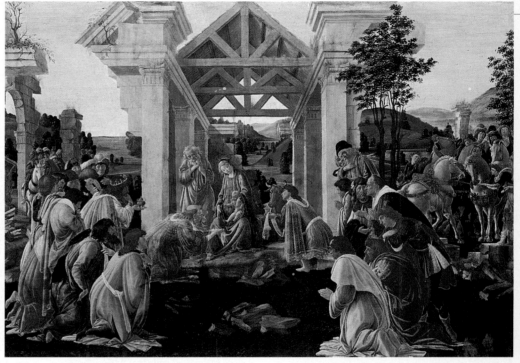

● Botticelli, through the mediation of the Vespucci family who helped him from the beginning, also entered the Medici circle – immortalizing it in the retinue accompanying the Magi in *The Adoration of the Magi* now in the Uffizi – and was able to participate in the Hellenistic current which arose in Florentine humanist culture.

● His contemporaries saw in him the new Apelles – the mythical classical Greek painter whose works are unknown – but for Botticelli the antique represents an aesthetic ideal, the ideal of the beautiful which is eternal, outside of history and time, the beauty of the intellectual light which is supreme knowledge itself, not a means for reaching it.

● In his representation of figures, "love of the pure lyricism of the line" goes so far as to make him sacrifice three-dimensionality in favor of an immaterial image lifted out of real space and historical time.

● Since at this point line no longer has the task of framing and explaining reality, perspective, understood as the way space is structured, no longer has a reason to exist. Botticelli's painting is thus deliberately anti-perspective, not in the sense that the artist does not know or breaks the rules of perspective, but in the sense that he does not consider them the fundamental principle for the construction of vision. In his last years the artist took this attitude to extremes, producing panels that increasingly utilized archaic and "primitive" solutions.

## THE PAZZI CONSPIRACY

A dramatic event took place in 1478 when a group of Florentines, led by the Pazzi family with the support of Pope Sixtus IV, plotted to overthrow the Medici power. The sacrilegious nature of the conspiracy reached its height during celebration of Mass in the cathedral. Giuliano de' Medici was mortally wounded, while Lorenzo, although struck, managed to escape. The enraged crowd chased the conspirators, who were arrested and put to justice. The Signoria of Florence engaged Botticelli to fresco the scene of the hanging on the walls of Palazzo Vecchio, but unfortunately the work has since been lost.

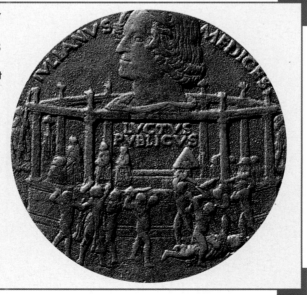

◆ THE ADORATION
OF THE MAGI
(1481-82, Washington,
National Gallery of Art).
The subject, a favorite
of the artist, was
painted by him
a number of times over
the course of his life.
This version recalls,
in its architectural
backdrop,
the analogous tondo
in the National Gallery
in London.

◆ PORTRAIT OF A MAN
HOLDING THE MEDAL
OF COSIMO THE ELDER
(1474, Florence,
Uffizi).
The presence of this
portrait in one of the
Medici houses led
for a long time
to the supposition
that the sitter was
a member of the family.
But closer examination
shows that the facial
features resemble
those of Botticelli as
he is portrayed in
*The Adoration of
the Magi*, and
thus it is
probable that
the model is
Antonio,
Sandro's
brother, who
resembled
him. Antonio
was a
goldsmith
and the
author of the
medal he holds
for the viewer to
observe.

◆ BERTOLDO
DI GIOVANNI
*Commemorative medal
of the Pazzi conspiracy*
(1478, Florence,
Museo Nazionale
del Bargello).
The medal, shown in
the box on the facing
page, represents
the head of Giuliano
de' Medici with
the inscription
"Luctus Publicus."

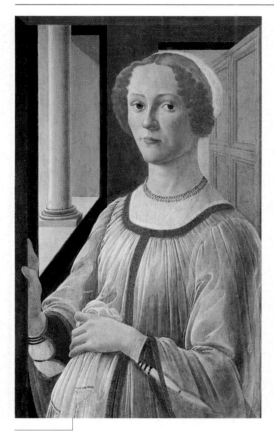

◆ THE ADORATION
OF THE MAGI
(1475, Florence, Uffizi).
The painting,
destined for the altar
of the funerary chapel
of Giovanni Zanobi del
Lama, in Santa Maria
Novella, has been
the object of particular
attention on the part
of scholars and art
historians, who have
tried to assign a name
to the figures
of the Medici court
shown here.
The identification
proposed at right
is the most accepted,
but certainly does not
claim to be definitive.
The painter's maturity
of style is evident
in the skill with which
he arranges the figures,
the harmony
of the colors,
and the preciousness
of the golden
embroidery.

◆ PORTRAIT OF
SMERALDA BRANDINI
(1470-71, London,
Victoria and Albert
Museum).
Formal research
and realistic analysis
are admirably united
in this portrait.

◆ PORTRAIT OF
GIULIANO DE' MEDICI
(1478, Washington,
National Gallery of Art).
This is the most
interesting version
of the various portraits
of Giuliano painted
by Botticelli.

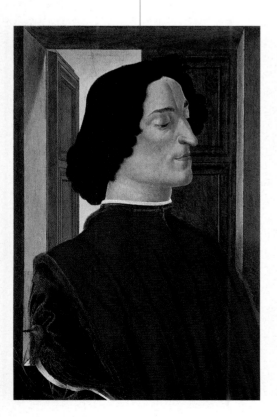

Lorenzo
the
Magnific

Angelo
Politian

Pico de
Mirand

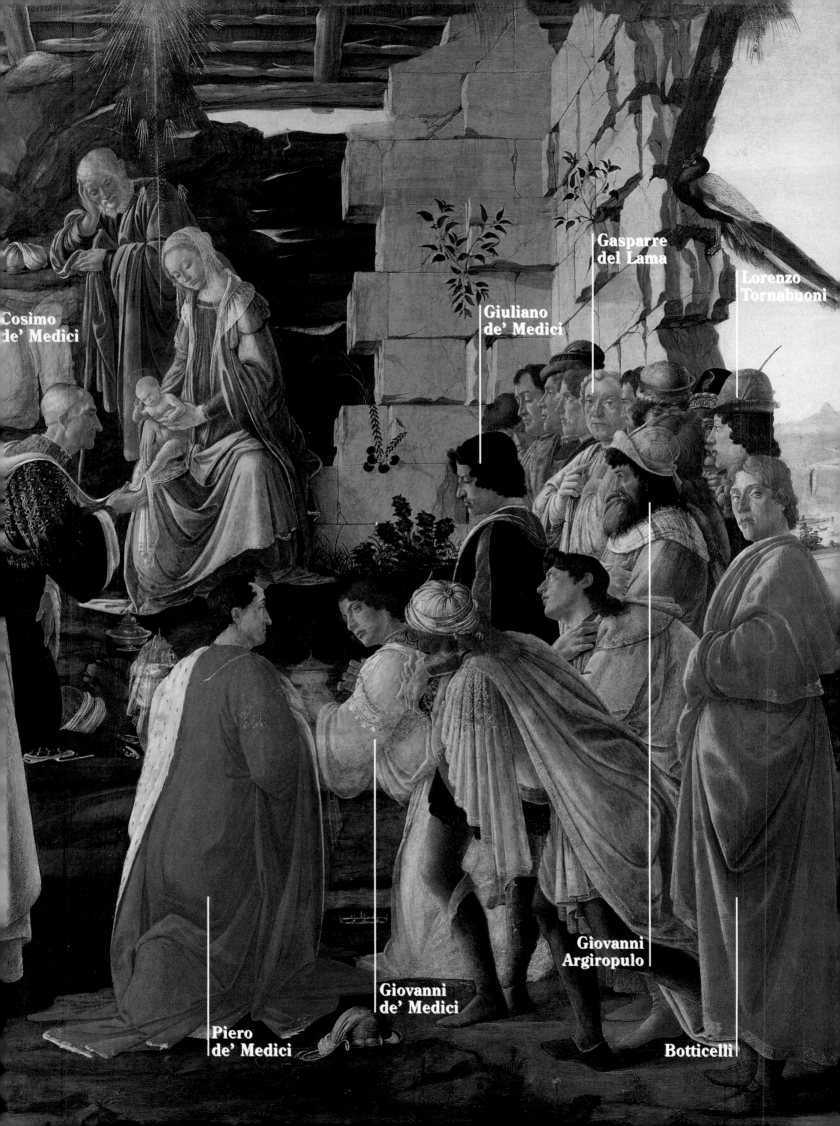

Cosimo
de' Medici

Gasparre
del Lama

Lorenzo
Tornabuoni

Giuliano
de' Medici

Piero
de' Medici

Giovanni
de' Medici

Giovanni
Argiropulo

Botticelli

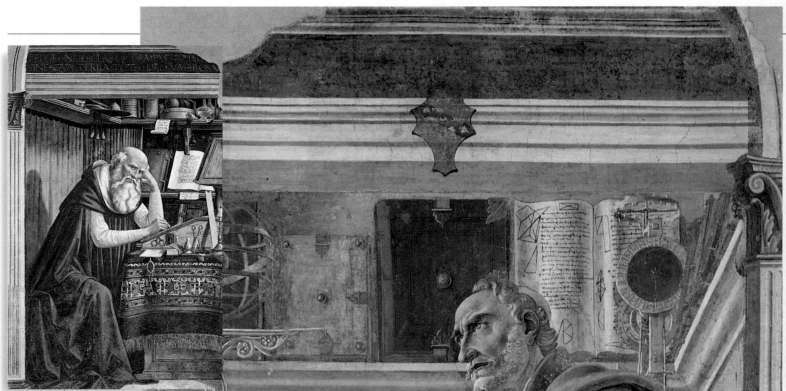

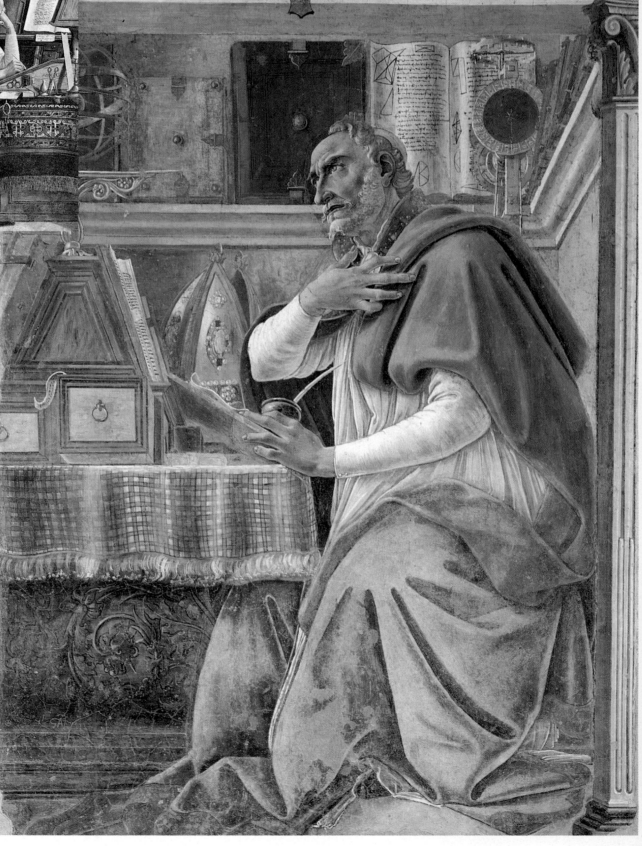

◆ DOMENICO
GHIRLANDAIO
*St Jerome*
(1480, Florence,
Church of Ognissanti).
Botticelli and
Ghirlandaio painted
at the same time
in the church
of Ognissanti the
frescoes of the two
saints, who were
greatly venerated
in the fifteenth century.
The saint
is represented as
a philologist among
the tools of his trade.

◆ ST AUGUSTINE IN
HIS STUDY
(1480, Florence,
Church of Ognissanti).
The saint is seen
by Botticelli as
the precursor of those
who held that
the Scriptures should
be interpreted
not literally but
according to
their spirit, and thus
he places within reach
an astrolabe, a book
of Pythagorean
theorems, and other
symbols of a humanist
culture profoundly
bound to the spirit
of Christianity.

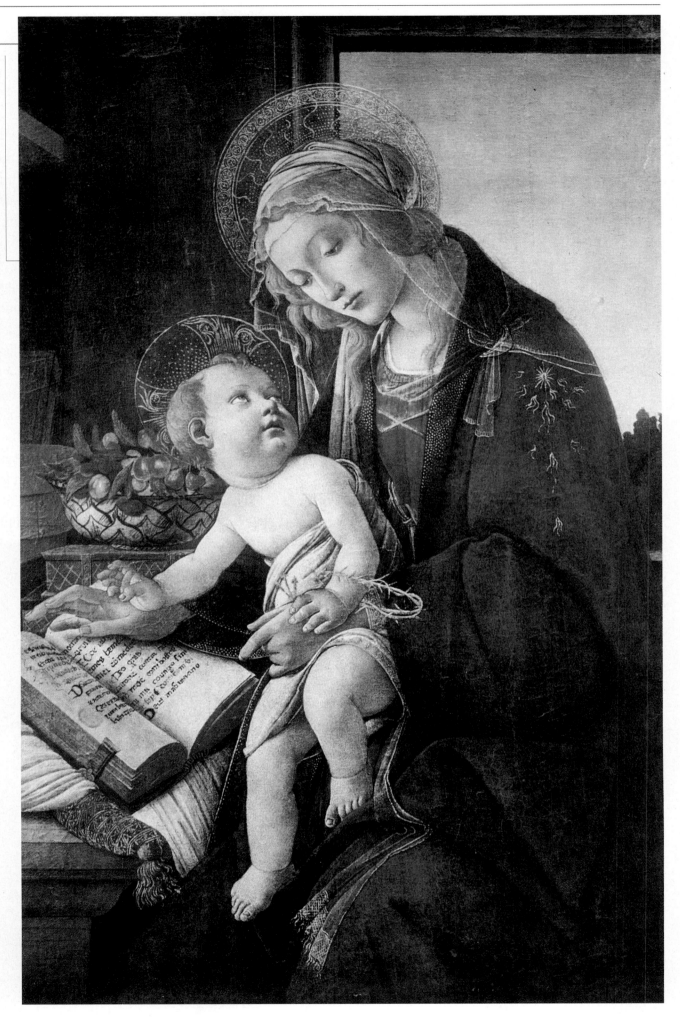

◆ THE VIRGIN
OF THE BOOK
(1480-83, Milan,
Museo Poldi Pezzoli).
The painting is
of very high quality
and reveals the
meticulous care
Botticelli took to define
the image in its linear
rhythms and the still
lifes of books lined up
on the shelf, the box,
the basket of fruit.
Mother and son show
an intense and
affectionate mutual
communication,
veiled by the presence
in the Child's hand
of the symbols of his
Passion. According
to some scholars,
the date of the picture
should be moved
to 1485.

# MYTH AND ALLEGORY

Toward the end of 1481 Botticelli was called to Rome to participate with Cosimo Rosselli, Piero di Cosimo, Domenico Ghirlandaio, and Perugino in the rich and complex program established by the humanist intellectuals at the papal court for the decoration of the Sistine Chapel; he was assigned to paint mainly historical themes. The artist, somewhat impatient of the limits imposed by the rules of traditional perspective construction, seems to revive in these frescoes the archaic compositional language characteristic of medieval painting.

● In a large number of devotional panels, Botticelli is able to express his style fully in a delicate graphic line and a highly refined palette, while the taste of the times emerges in a certain secular tone in the sacred composition. But besides this activity, which nonetheless occupied a large part of his time, since especially his tondos with images of the Virgin were in great demand, the artist devoted himself in this decade to works with a mythological content, reinterpreted in the light of Neoplatonic philosophy.

● Botticelli transferred to the world of myth an intense spirituality, manifested in a series of images imbued with a moral content corresponding to his patron's ideals. The fresco cycle for Villa Lemmi, of which some traces remain, and that for the villa at Spedaletto (of which nothing survives) are, together with *The Allegory of Spring*, *The Birth of Venus*, and *Pallas and the Centaur* the highest expression of the urgency of the ethical message.

● The serene tone of these works at times yields to melancholy and immerses the figures, detached from the action, in a contemplative mood. Action is transferred from the exterior to the interior and becomes a process of inner sifting and refinement.

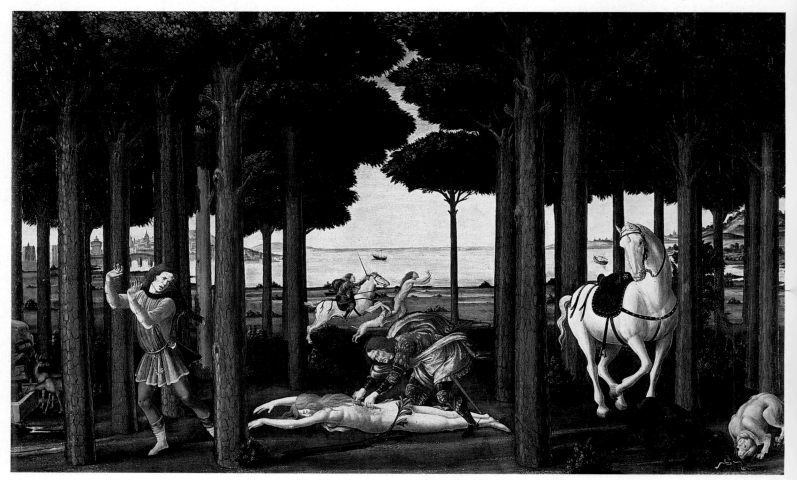

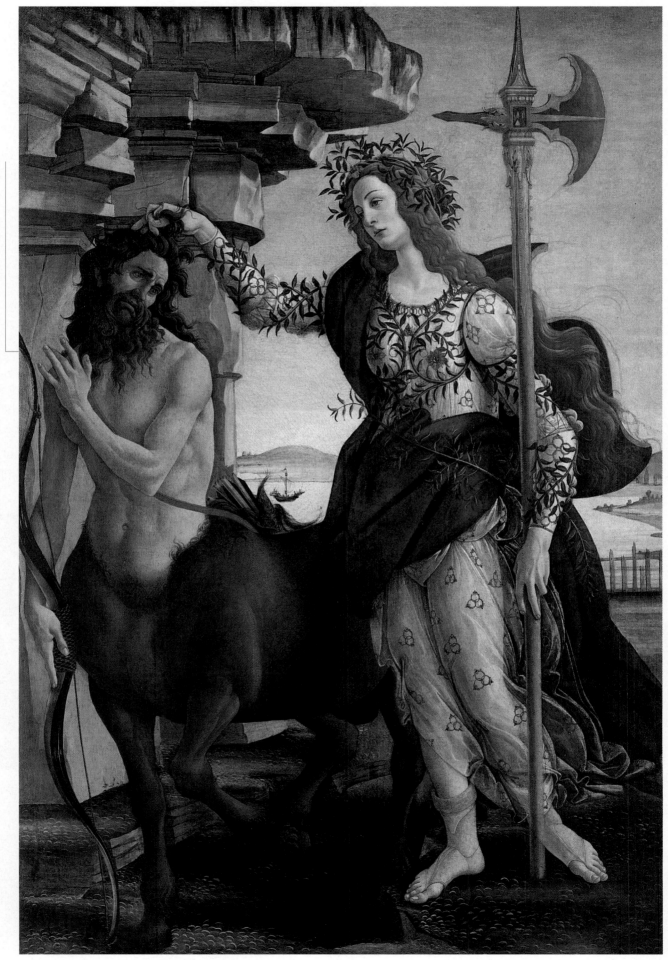

♦ THE MADONNA OF THE MAGNIFICAT (1482-83, Florence, Uffizi). In the tondo on the facing page, the aristocratically beautiful figures manifest an intense spirituality.

♦ PALLAS AND THE CENTAUR (1482-83, Florence, Uffizi). The symbolic meaning of the picture has evoked political interpretations and philosophical readings explaining the dual nature of the centaur. The goddess of Reason dominates the beast, i.e., the human instinct resident in the lower parts of the body, by grabbing the centaur by the hair, appealing to his rational side, which corresponds to the upper half. The goddess wears a dress decorated with Medici emblems and is wrapped in myrtle branches.

♦ THE STORY OF NASTAGIO DEGLI ONESTI (1483, Madrid, Prado, second panel). Botticelli's narrative vein finds expression in a series of four panels narrating the story told by Boccaccio in his *Decameron* (V, 8). The panel shown here presents the dramatic moment when Nastagio in horror sees the knight taking the fallen girl's heart and giving it to the dogs to eat. The panels were commissioned for the wedding of Giannozzo Pucci and Lucrezia Bini.

◆ THE VIRGIN OF THE
POMEGRANATE
(1487,
Florence, Uffizi).
The tondo was painted
for the Audience
Chamber of the
Magistrati di Camera
in Palazzo Vecchio.
The Virgin's face,
very similar to that of
Venus, has a detached,
spiritual expression,
accentuated by the
presence in the Child's
hand of a pomegranate,
symbol of his future
Passion. The six angels
arranged around
the Virgin in receding
planes are surmounted
by a golden oval that
alludes to divine light.

◆ VENUS AND MARS
(1483, London,
National Gallery).
Many literary sources
relate the love story
of Mars and Venus
and could have served
as inspiration for this
painting: from Marsilio
Ficino to Politian,
from Lucretius
to Lucian, from Luigi
Pulci to Lorenzo
the Magnificent.
A Roman sarcophagus
representing Bacchus
and Ariadne presents
the same scheme
of the two bodies,
one nude, the other
dressed, lying facing
each other.
The presence of the
wasps (*vespe* in Italian)
on the tree trunk
suggests a reference
to the Vespucci family,
who probably
commissioned
the picture.

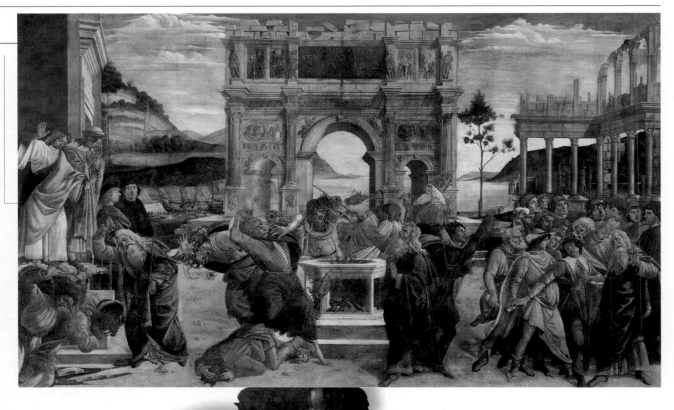

◆ THE PUNISHMENT OF THE REBELS (1481-82, Rome, Palazzi Vaticani, Sistine Chapel). Three pieces of architecture (a Renaissance palace on the left, the Arch of Constantine in the center, and the *Septizodium* on the right) provide the backdrops for the three separate episodes: Joshua keeps the Jews from stoning Moses and Aaron, the rebellion against Aaron's authority, the punishment of the Levites.

♦ THE FARNESE CUP
(2nd century B.C.,
Naples, Museo
Archeologico Nazionale).
The winged genii on this
ancient sardonyx cameo,
once the property of
Lorenzo the Magnificent,
inspired the figures
of Zephyrus and Aura.

♦ THE BIRTH OF VENUS
(1482-83,
Florence, Uffizi).
The painting, along
with *The Allegory of
Spring*, hung in the
Medici villa at Castello.
Once again *Le Stanze*
(I, 41-64) by Angelo
Politian are the literary
source that inspired
the painter.
The episode is the one
in which Venus,
who has just been born
of the foam of the wave,
is transported to the
island of Cythera
"on a shell,"
propelled by the winds
Zephyrus and Aura.
Welcoming her is one
of the Spring Hours,
in a white dress
scattered with daisies,
who holds out a cloak
to cover her nudity,
which she modestly
tries to hide
with her hands.
The nude Venus has
its iconographical
source in an ancient
sculpture of the type
called the *Venus pudica*,
or "modest Venus,"
known from numerous
originals and copies.

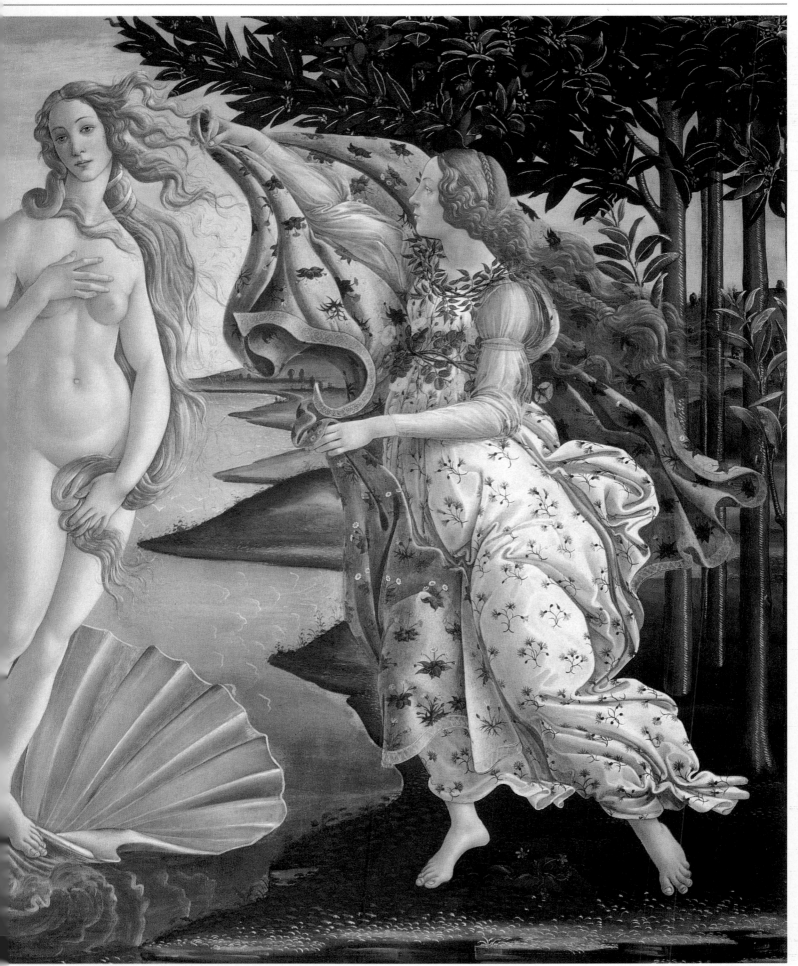

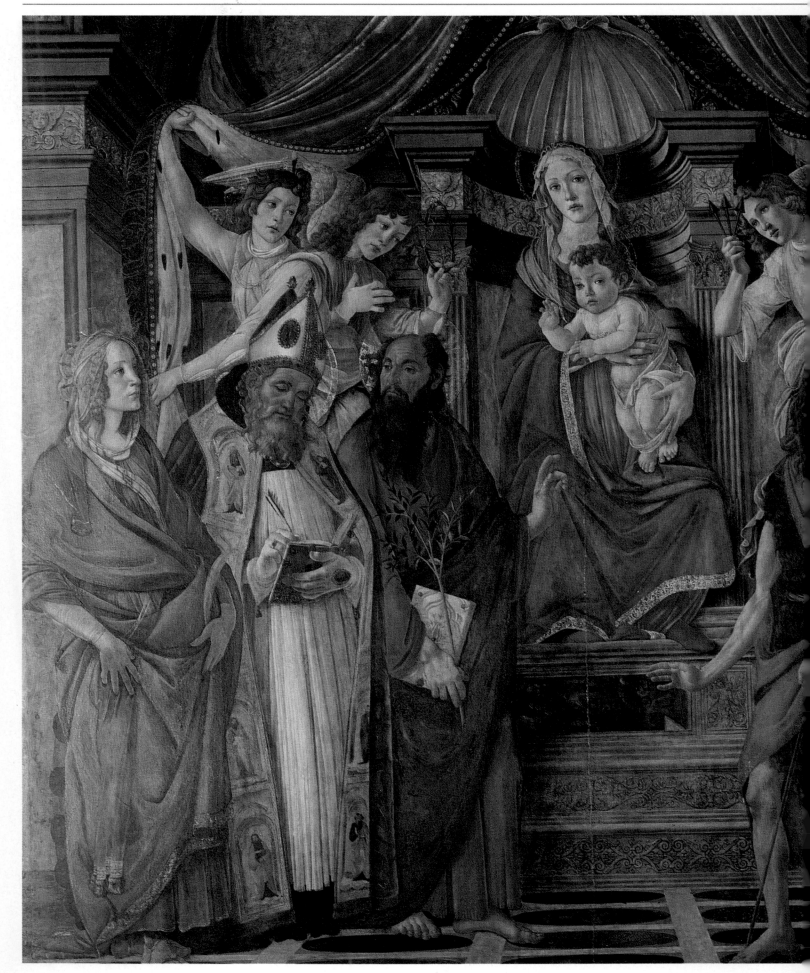

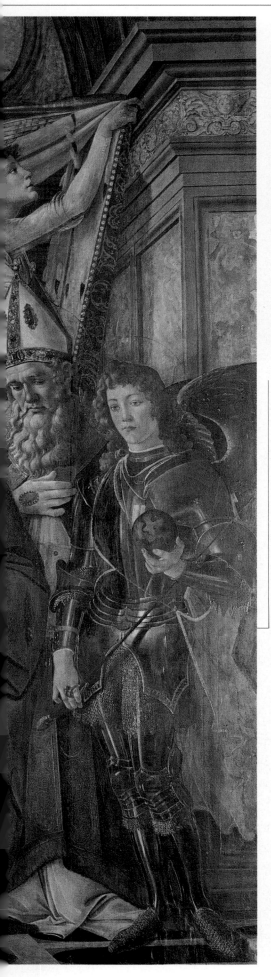

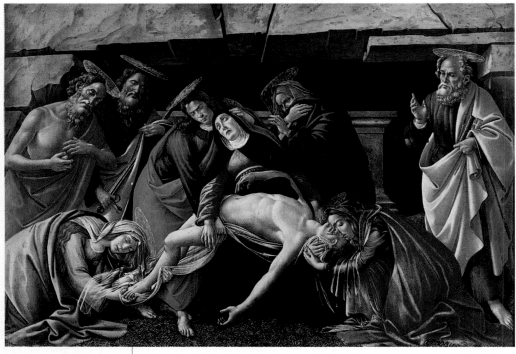

◆ THE VIRGIN AND
CHILD WITH SAINTS
CATHERINE
OF ALEXANDRIA,
AUGUSTINE, BARNABAS,
JOHN THE BAPTIST,
IGNATIUS,
AND MICHAEL
THE ARCHANGEL
(c. 1489,
Florence, Uffizi).
Known as the
*St Barnabas Altarpiece*,
the panel was
commissioned
by the Guild of Doctors
and Pharmacists
for the church
of San Barnaba.
An elaborate canopy
falls around
the classicizing marble
throne of the Virgin.
The composition
reveals in part
the artist's new
direction of research,
no longer seeking
"ideal beauty,"
but now focusing
on the suffering,
intense expression
of the drama.
The Virgin, St Michael,
the angels, and
St Catherine still
belong to his preceding
stylistic phase, while
the other saints reflect
the search for a new
language that has not
yet been fully defined.

◆ LAMENTATION
OVER THE DEAD CHRIST
(1489-92, Munich,
Alte Pinakothek).
The dramatic power
of the composition
is obtained through
a series of closed
triangles within which
the figures are inserted
by force, making them
seem oppressed
and dominated by their
grief at the loss they

have just suffered.
The sense of
oppression is
heightened by the rock
wall overhanging
the scene and
containing the
sarcophagus
in which Christ will be
entombed. The strong
contrast between
the colors and
the leaden tones
of the flesh contributes

to giving the
composition an openly
dramatic tone which
prefigures Botticelli's
more openly
"Savonarolian" phase.
The search for
a disembodied "beauty"
is still present
in the figure of Christ,
while the face of
St John, next to
the Virgin, is strongly
expressive.

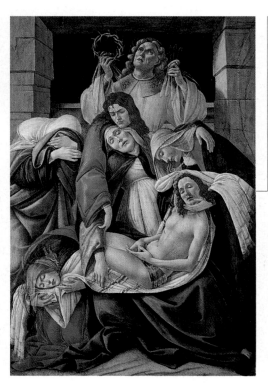

◆ LAMENTATION
OVER THE DEAD CHRIST
(1495, Milan,
Museo Poldi Pezzoli).
The panel repeats
the theme of the
picture in Munich
painted a few years
earlier.
Here the figures
constitute
one compact block,
weighty with drama.
The strongly
expressive faces
and bodies
are twisted in pain.
Notice in particular
the figure
of Mary Magdalene
at lower left
tenderly embracing
Christ's feet,
crouching
in a stylized
and unnatural curve.

# THE CRISIS YEARS

The mythical Golden Age, greeted with great enthusiasm in Florence by men of culture, was already on the wane. Lorenzo the Magnificent's policy of equilibrium was showing signs of cracking, and the economic and political situation in the last decade of the century was increasingly unstable. The contradictions evident in the city were denounced by the Dominican friar Gerolamo Savonarola. His sermons spared neither politics nor culture; they stirred up his followers (called i *Piagnoni*, or the "weepers") against the humanists and philosophers accused of paganism, against the artists who created indecorous images, against the victors of a tyrannical form of politics. The "bonfires of the vanities" organized between 1497 and 1498 indicate how little was left by that time of the Florentine cultural supremacy of which all had been so proud.

● Everyone was invited to repent and to convert radically. The most restless, but also the most sincere, spirits were profoundly disturbed and pulled in by the friar's apocalyptic visions; among these was Sandro Botticelli, who now proposed

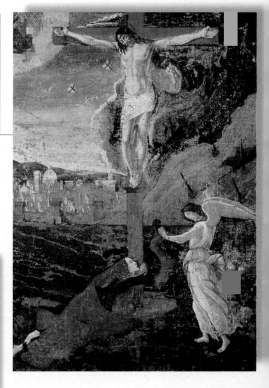

◆ THE MYSTIC CRUCIFIXION (1500-05, Cambridge, Massachusetts, Fogg Art Museum). Botticelli here eschews perspective, proportions, and drawing, succeeding in reaching great heights in the figure of Mary Magdalene, wrapped in her cloak and prostrate at the foot of the Cross.

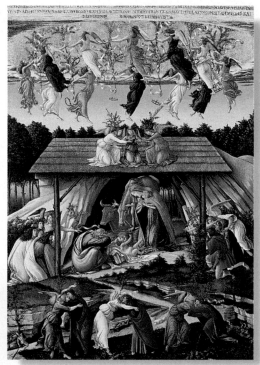

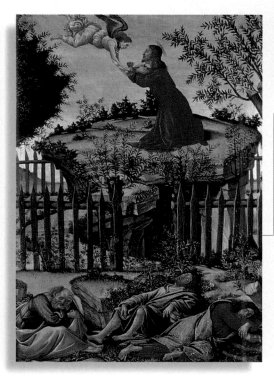

◆ CHRIST PRAYING IN THE GARDEN OF GETHSEMANE (c. 1500-04, Granada, Capilla de los Reyes). The small panel was painted for Isabella the Catholic, Queen of Castille. Stylistically it belongs to the same period as the other two panels, whose narrative simplicity and deliberately archaic composition it shares.

darker, more leaden tones in his sacred works. *Calumny* is the last mythological subject he painted, perhaps in response to the atmosphere of general suspicion generated by the conflicts between the factions.

● In his fury of renewal, the friar also attacked the pope, Alexander VI, and the Curia. The Florentine government in May 1498 took advantage of the pope's withdrawal of support to accuse Savonarola of immorality and to have him arrested and sentenced to death (May 23, 1498).

● Botticelli paid no heed to the accusations leveled at the friar and took refuge in his work with renewed zeal. The sacred panels present subjects which are given symbolical interpretations, while the fever of his mysticism grew hotter and hotter, leading him to seek a more archaic and expressive language.

● In a changed climate under the leadership of the Gonfaloniere della Repubblica Pier Soderini, in his last years Botticelli was once again an inexhaustible narrator of stories: those of Virginia, of Lucretia, and of St Zenobius, his last known work.

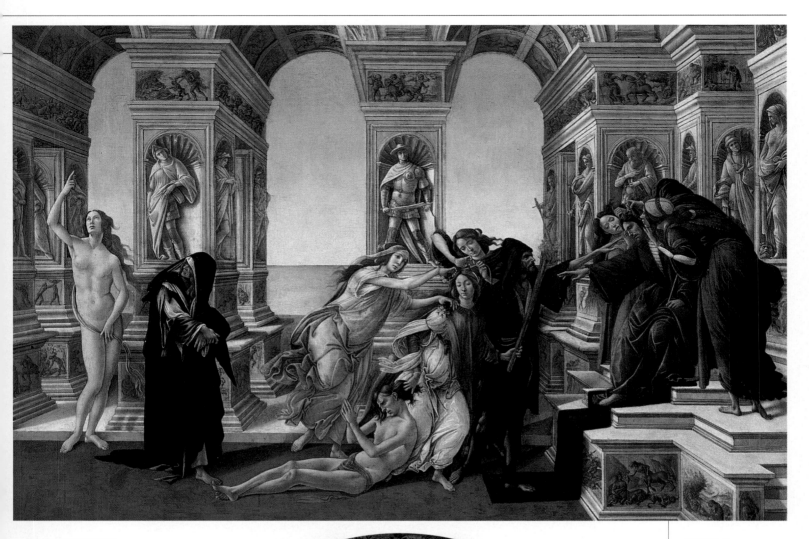

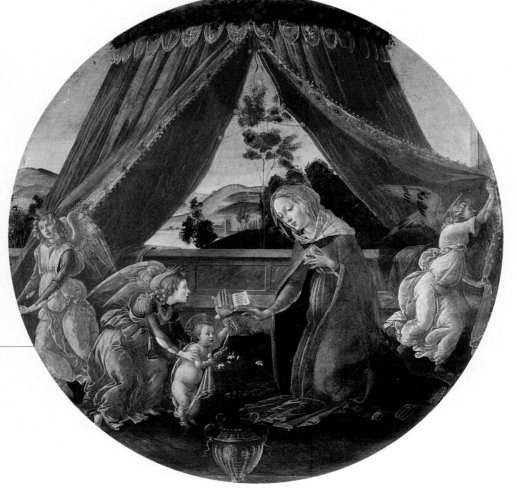

◆ THE MYSTIC NATIVITY
(1501, London,
National Gallery).
On the facing page,
in the center, is the most
significant work of the
phase of his Savonarolian
mysticism. Archaic in
structure, the panel
evokes passages from
the Bible's *Book of
Revelations* and is
deliberately cryptic, as is
indicated by the Greek
words across the top.

◆ THE VIRGIN
OF THE PAVILION
(c. 1493,
Milan, Pinacoteca
Ambrosiana).
The tondo is of very
high quality and
is probably the one
Vasari saw
in the convent of
Santa Maria degli
Angeli, which
no longer exists. It is
not clear how it came
to Milan, but it could
have been a gift of
Charles VIII of France
to the Duke of Milan.

◆ CALUMNY
(c. 1495, Florence,
Uffizi). The subject of
the painting by
the Greek artist Apelles
was known to Botticelli
from the descriptions of
it made by Lucian and
Alberti. The scene is set
in a rich hall decorated
with reliefs and statues.
On the right King
Midas, depicted with
ass's ears, listens
to the murmurings
of Suspicion and
Ignorance, while in front
of him, Hatred leads
in Calumny, followed by
Envy and Fraud,
who braid her hair with
flowers and ribbons.
The victim of slander
is dragged in nude by
the hair, begging with
clasped hands for
mercy. At a short
distance a withered
and bony old woman,
dressed in black
and white, Repentance,
turns toward Truth,
a nude woman pointing
towards heaven.

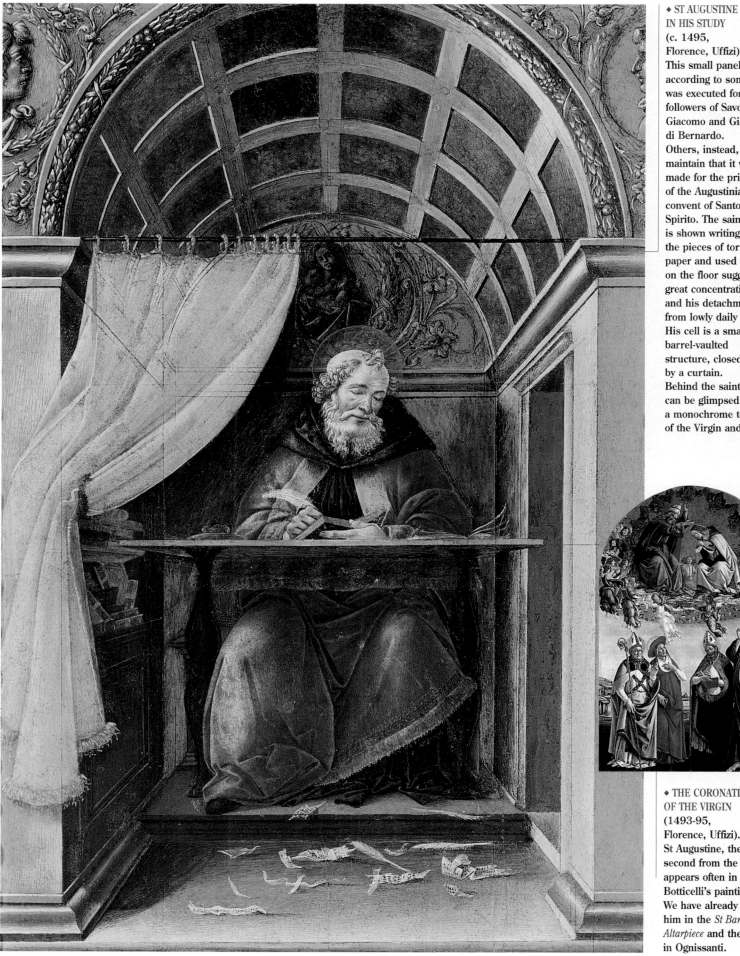

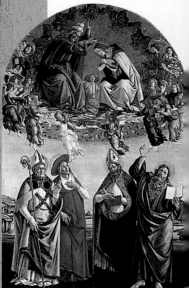

♦ ST AUGUSTINE
IN HIS STUDY
(c. 1495,
Florence, Uffizi).
This small panel,
according to some,
was executed for two
followers of Savonarola,
Giacomo and Giovanni
di Bernardo.
Others, instead,
maintain that it was
made for the prior
of the Augustinian
convent of Santo
Spirito. The saint
is shown writing;
the pieces of torn
paper and used quills
on the floor suggest his
great concentration
and his detachment
from lowly daily cares.
His cell is a small
barrel-vaulted
structure, closed off
by a curtain.
Behind the saint
can be glimpsed
a monochrome tondo
of the Virgin and Child.

♦ THE CORONATION
OF THE VIRGIN
(1493-95,
Florence, Uffizi).
St Augustine, the
second from the left,
appears often in
Botticelli's paintings.
We have already seen
him in the *St Barnabas
Altarpiece* and the fresco
in Ognissanti.

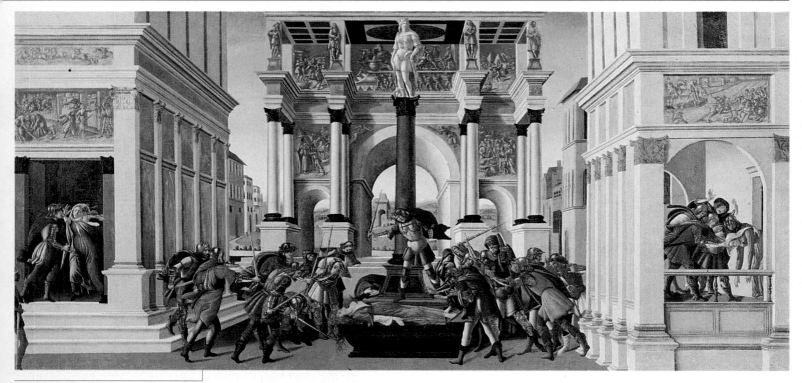

♦ STORIES FROM THE LIFE OF LUCRETIA (c. 1500, Boston, Isabella Stewart Gardner Museum).
The literary sources inspiring this painting are Livy and Valerius Maximus. The narrative force is manifested not only in the main story, but also in the episodes described in the friezes on the architecture: the story of Judith on the left; the episodes of Marcus Curtius and Mucio Scaevola in the friezes on the triumphal arch; the feats of Horatius Cocles in the frieze over the arch on the right. The main story unfolds in three different moments. On the left, Lucretia tries to repel the advances of Sextus, the son of Tarquin the Proud; on the right, Lucretia's suicide after being dishonored by Sextus; in the center, the culmination of the drama with Brutus showing her body to the Roman soldiers, inciting them to revolt. The architectural backdrops recall in some ways the perspective of Piero della Francesca and reiterate the concept that high drama is developed only against the background of great ideas.

♦ EPISODES FROM THE LIFE OF ST ZENOBIUS: THE THREE MIRACLES (c. 1505, London, National Gallery).
The story of St Zenobius, bishop of Florence, who lived between the fourth and fifth centuries, unfolds along four panels. The one shown below is the second, and presents the bishop freeing two youths possessed by demons on the left, raising the son of a noblewoman in the center, and restoring sight to a blind man on the right. The simplicity of the architectural forms in the background underlines Botticelli's polemical response to the formulations of aerial perspective being offered by Leonardo. Botticelli's architecture and his narrative candor recall, on the contrary, the perspective solutions of Fra' Angelico or, even farther back in time, of Giotto, with the perspective planes understood as pure fields of color, in front of which the composition is arranged by groups.

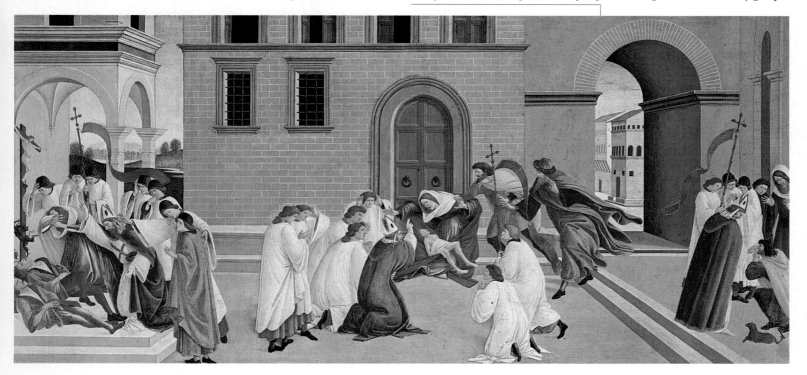

# THE GLORY OF THE RENAISSANCE

The dignity of man is a central theme of the Renaissance, and it is celebrated through the value attributed to the arts, techniques, and doctrines which man uses to conquer nature, impart an order to society, increase his knowledge of the world, and appreciate life's beauties, as Pico della Mirandola does in the *Oratio de hominis dignitate* or Leon Battista Alberti in his *Libri della famiglia*.

● The concentration of genius in Florence during this period is truly impressive in every field: Raphael, Michelangelo, Masaccio, Leonardo, Botticelli, Donatello, Brunelleschi, Pietro Aretino, Politian, Alberti, Machiavelli, Guicciardini, Marsilio Ficino, and Pico della Mi-

♦ ANTONIO DEL POLLAIOLO *Hercules and Antaeus* (c. 1475, Florence, Museo del Bargello).

randola are just some of the personalities who emerged from this culture.

● Their talents served not only to create masterpieces, but often revolutionized their disciplines at the foundation. This was the epoch in which, in painting, perspective, portraiture, landscape, and still life were reborn; in sculpture, the portrait bust and equestrian statue; in music, the madrigal. The first secular dramas in Italian were performed, and tragedy, comedy, and pastoral all found new life. The first modern theories of art, literature, poetry, philology, and politics were developed.

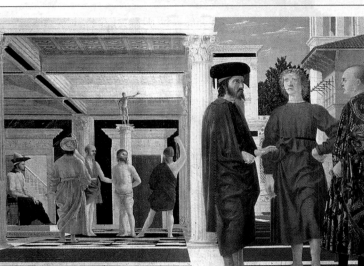

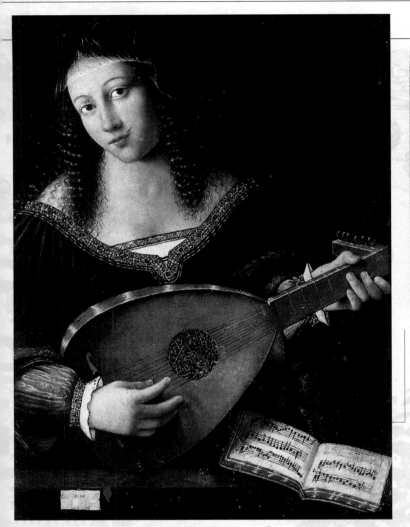

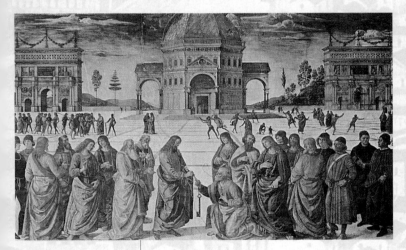

◆ BARTOLOMEO VENETO
*Woman Playing the Lute*
(15th century, Florence, Uffizi). Music plays an important role in the Renaissance and is closely connected with the written text. In the vocal composition of the madrigal, every element of sound is placed at the service of the word.

◆ PIERO DELLA FRANCESCA
*The Flagellation of Christ*
(after 1459, Urbino, Galleria Nazionale delle Marche). The use of allegory in Renaissance works is very frequent and often so difficult to interpret as to render almost impossible a reading that goes beyond close literal deciphering. This is the case of the *Flagellation*, in which the apparent subject conceals the profound meaning of the picture, over which critics and historians have labored for years to formulate the most suggestive hypotheses to explain it.

◆ GIULIANO DA SANGALLO
*The Villa at Poggio a Caiano*
(1480-85). On the facing page is one of the most successful examples of architecture in symbiosis with the surrounding landscape. The loggia, terraces, and large windows enter into a direct dialogue with nature.

◆ PIETRO PERUGINO
*Christ Giving the Keys to St Peter*
(1481-82, Rome, Palazzi Vaticani, Sistine Chapel). This fresco faces the one by Botticelli on the Sistine Chapel walls, and it may have been just this empirical space so precisely defined that irritated Botticelli and pushed him toward an idealistic, absolute, and difficult art.

◆ GIOVANNI PICO DELLA MIRANDOLA
(15th century, Florence, Uffizi). The Italian intellectual, here in an anonymous portrait, had as his guiding idea the *pax philosophica* capable of bringing together the proponents of all the doctrines of thought in the name of the dignity of man, understood as the supreme embodiment of the spiritual world.

# A COMPLEX LESSON

No particularly interesting artistic personalities emerged from Botticelli's workshop, with the exception of Filippino Lippi, the son of the Filippo Lippi from whom Botticelli had learned the first elements of painting. In the beginning the student followed the master's style so closely that Filippino's earliest paintings are mistaken for Botticelli's. Only later did Lippi distinguish himself from his teacher by a certain exasperation of linearism.

● The master's fame was great, as witnessed by the fact that in 1504 he was named to the committee assembled to decide where Michelangelo's *David* was to be placed. He suggested putting the statue on the cathedral steps, but his opinion was not supported. His appointment was an act of homage to his art, but he was already considered to have been left behind by the new taste which preferred the emerging talents of Michelangelo and Raphael.

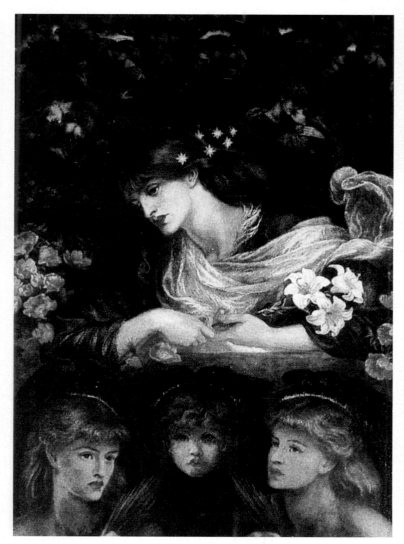

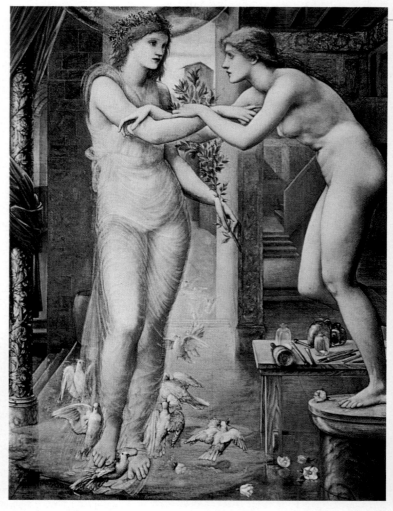

● Critical appreciation of Botticelli was quite modest until the late eighteenth century, and he was recognized only as the painter of the frescoes in the Sistine Chapel. It would be the nineteenth century before the myth of the artist would be born, and this was mainly the claim of the Romantics and Decadents. Above all, it was English culture and taste which paid him the attention he was due.

● The ecstatic, dreamy female faces painted by Botticelli appealed greatly to the English Pre-Raphaelite school, in particular to Edward Burne-Jones, Dante Gabriel Rossetti, and William Holman Hunt. They without doubt had the opportunity in England to study Botticelli's images, even in simple reproductions, and to take from them the rhythmic play of line aimed at creating an aesthetic ideal of perfection. The faces he painted represented a model of reference even if their femininity is reinterpreted in a dark and passionate or enigmatic key, prefiguring the myth of the androgynous figure.

◆ EDWARD
BURNE-JONES
*The Story of Pygmalion:
the Goddess Gives Life*
(1869-79,
Birmingham
City Museum
and Art Gallery).
The sense of the end
and above all the ideal
of beauty create
a relationship between
two artists distant
in time like Botticelli
and Burne-Jones.

◆ DANTE
GABRIEL
ROSSETTI
*The Blessed
Damosel*
(1875-78,
Cambridge,
Massachusetts,
Fogg Art Museum).
Through Botticelli
the painter goes back
in time all the way
to the taste of the
*Dolce stil novo*.

◆ PORTRAIT
OF A YOUTH
(1483-84, London,
National Gallery).
The critic Horne
considers the sitter
to be one of the young
boys in Botticelli's
workshop.
The portrait, long
thought to be the work
of Filippino Lippi,
belongs to the phase
in which it is easy
to confuse the student's
hand and the master's.

### ◆ FORTITUDE (1470)

Commissioned by the magistrates of the Tribunale della Mercanzia, it was painted as part of a series of *Virtues*, already begun by the master, Piero del Pollaiolo in 1469. This was Botticelli's first public commission, which brought him to the attention of others beyond his small circle of friends. The great plastic force of the figure is emphasized by her red cloak, a quality that reveals Pollaiolo's still strong influence.

### ◆ THE VIRGIN AND CHILD SURROUNDED BY ANGELS (1470)

This image reproposes the classical motif of the Virgin enthroned, but reworked in a careful graduation of the volumes. Golden rays surround the figure, overlaid with a frieze of cherubs' heads. The Virgin, seated frontally on her throne with her head turned slightly to the right, is powerfully modeled.

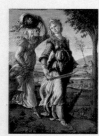

### ◆ THE DISCOVERY OF THE BODY OF HOLOFERNES (1472)

This Biblical subject appears often in fifteenth century painting, and Botticelli himself repeated it in a later version. It originally formed a diptych with *Judith's Return to Bethulia*. The scene is set inside Holofernes's tent, with his body in the foreground. The court dignitaries shown in the act of discovering it are dressed in elaborate Oriental costumes.

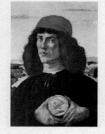

### ◆ JUDITH'S RETURN TO BETHULIA (1470-72)

The scene captures the triumphal moment of Judith's return to her city, accompanied by her handmaid bearing the severed head of Holofernes. Judith carries in one hand the sword used to kill the Assyrian general, in the other an olive branch, the symbol of peace. The episode takes place contemporaneously with *The Discovery of the Body of Holofernes*.

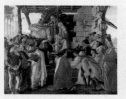

### ◆ PORTRAIT OF A MAN HOLDING THE MEDAL OF COSIMO THE ELDER (1474)

The facial features of the model here recall the portrait of Botticelli in *The Adoration of the Magi*, and it is thus probable that he is Antonio, Sandro's brother, who resembled him. Antonio was a goldsmith, who made the medal which he offers so prominently for the viewer's observation.

### ◆ THE ADORATION OF THE MAGI (1475)

The painting, destined to the chapel of Giovanni Zanobi del Lama in Santa Maria Novella, was the object of particular attention on the part of scholars, who attempted to identify in it the members of the Medici court. The painter arranges the figures, dressed in garments richly embroidered with gold thread, with great stylistic maturity in a harmonious range of colors.

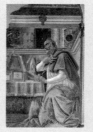

### ◆ ST AUGUSTINE IN HIS STUDY (1480)

Botticelli sees the saint as the first representative of the current of exegetes who maintained that the Scriptures should be interpreted by their spirit rather than literally. For this reason, he places within the scholar's reach an astrolabe, a book of Pythagorean theorems, and other symbols of humanistic culture which were profoundly linked to the spirit of Christianity.

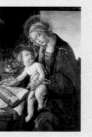

### ◆ THE VIRGIN OF THE BOOK (1480-83)

This painting, of very high quality, reveals the care Botticelli took to define the image in its linear rhythms and the still lifes of the books lined up on the shelf, the box, and the basket of fruit. The mother and son show an intense, affectionate mutual communication which is veiled by the presence in the Child's hand of the symbols of his Passion.

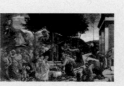

### ◆ THE TRIALS OF MOSES (1481-82)

The story of Moses is divided into episodes represented in the same space, separated by elements of the landscape, according to medieval custom. Moses kills the Egyptian and escapes onto the mountain; he drives away the Midianite shepherds so that the herds of the daughters of Jethro can drink; he is shown barefoot on Mount Sinai as he is revealed the sign of God in the burning bush, and he departs for the Promised Land.

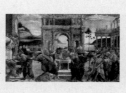

### ◆ THE PUNISHMENT OF THE REBELS (1481-82)

Three pieces of architecture (a Renaissance palace on the left, the Arch of Constantine in the center, and the *Septizodium* on the right) provide the backdrops for three different episodes: Joshua preventing the Jews from stoning Moses and Aaron, the contesting of Aaron's authority and the incense rising to heaven, and the punishment of the rebel Levites.

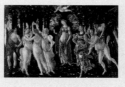

### ◆ THE ALLEGORY OF SPRING (c. 1482)

Zephyrus captures the nymph Chloris and impregnates her; flowers emerge from her mouth, and she is transformed into the goddess Flora. Dominating the center is the standing figure of Venus, while above her head a flying Cupid is about to shoot a flaming arrow toward one of the Graces. On the far left Mercury lifts his caduceus toward the top of the trees to keep away the clouds.

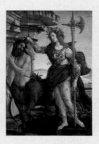

### ◆ PALLAS AND THE CENTAUR (1482-83)

The painting has a strong symbolic charge and has been interpreted both in a political key (as an allegory of the diplomatic successes of Lorenzo the Magnificent) and in connection with the prevailing Platonic climate, which explains the dual nature of the centaur. The goddess of Reason dominates the beast, or instinct, grasping the centaur by the hair.

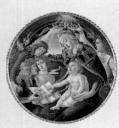

### ♦ THE MADONNA OF THE MAGNIFICAT (1482-83)

The Virgin is intent on writing a canticle in a small Prayerbook, while an angel, in an exquisite intertwining of hands, holds an inkwell for her to dip her pen. All the figures have an aristocratic beauty and betray no feeling except an intense spirituality. The contour lines define almost flat forms, which are made even lovelier by lacquered surfaces and gilding.

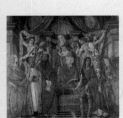

### ♦ THE BIRTH OF VENUS (1482-83)

This painting hung with *The Allegory of Spring* in the Medici villa at Castello. Once again, Politian's *Le Stanze* (I, 41-64) provide the direct literary source. The moment shown is that in which Venus, just born from the seafoam, is transported to the island of Cythera "on a shell," propelled by the winds Zephyrus and Aura. Waiting to greet her is an Hour of Spring.

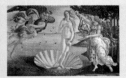

### ♦ VENUS AND MARS (1483)

Texts by Marsilio Ficino, Politian, Lucretius, Lucian, Luigi Pulci, and Lorenzo the Magnificent may have inspired the painting. A Roman sarcophagus, representing Bacchus and Ariadne, presents the same scheme of the two bodies, one nude and the other dressed, facing each other. The motif of the wasps on the tree trunk suggests that the Vespucci family could have commissioned the work (wasp in Italian=*vespe*).

### ♦ THE STORY OF NASTAGIO DEGLI ONESTI (1483)

Botticelli's narrative vein finds expression in a series of four panels telling a story from Boccaccio's *Decameron* (V, 8). The first, second, and third panels are in the Prado, the fourth in a private collection. The panels were commissioned for the wedding of Giannozzo Pucci and Lucrezia Bini.

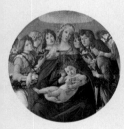

### ♦ THE VIRGIN OF THE POMEGRANATE (1487)

The tondo was painted for the Audience Chamber of the Magistrati di Camera in Florence's Palazzo Vecchio. The face of the Virgin has a detached, spiritual expression, heightened by the presence of a pomegranate, symbol of the Passion to come. The six angels arranged around the Virgin recede into depth, while above them hovers a golden oval, alluding to divine light.

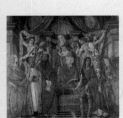

### ♦ THE ST. BARNABAS ALTARPIECE (ca. 1489)

The panel was commissioned by the Guild of Doctors and Pharmacists for the church of San Barnaba. An elaborate canopy falls around the marble, classicizing throne of the Virgin. The composition shows in part the new tendency of the artist, no longer devoted to the search for "ideal beauty," but the deeply felt, intense expression of drama.

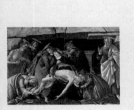

### ♦ LAMENTATION OVER THE DEAD CHRIST (1489-92)

The dramatic nature of this composition is achieved through a series of closed triangles into which the figures are forced, giving them the sense of being oppressed and dominated by their grief at the loss they have just suffered. This oppressive pain is accentuated by the rock wall looming over the scene, holding the sarcophagus in which Jesus will be laid.

### ♦ THE VIRGIN OF THE PAVILION (c. 1493)

This fine tondo can probably be identified as the one Vasari saw in the now suppressed convent of Santa Maria degli Angeli. Especially beautiful in the arrangement of the figures, its style belongs to the artist's most mature phase. It is not yet clear how it came to Milan, but it could have been a gift from Charles VIII of France to the Duke of Milan.

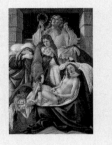

### ♦ LAMENTATION OVER THE DEAD CHRIST (c. 1495)

The panel repeats the theme already treated a few years earlier. This time the figures are united into one compact block weighty with drama. The strongly expressive faces and bodies are twisted in grief. Particularly noteworthy is the figure of Mary Magdalene, at lower left, lovingly holding Christ's feet and crouching in a completely unnatural position.

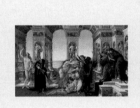

### ♦ CALUMNY (c. 1495)

The subject of the painting by the Greek artist Apelles was known to Botticelli from the descriptions given by Lucian and by Alberti. The scene is set in a magnificent hall decorated with reliefs and statues. On the right King Midas is listening to Suspicion and Ignorance. In front of him are Hatred, Calumny, Envy, and Fraud. The victim of slander is being dragged in by his hair. At a slight distance, Repentance turns toward Truth.

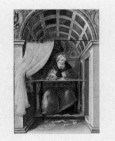

### ♦ ST AUGUSTINE IN HIS STUDY (c. 1495)

The saint is shown intent at his writing. On the floor, torn-up pieces of paper and used quills suggest his great concentration and his detachment from mundane cares. The cell is presented as a small barrel-vaulted structure closed off by a curtain. Behind St. Augustine can be glimpsed a marble tondo.

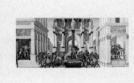

### ♦ STORIES OF LUCRETIA (c. 1500)

The story takes place in three times. On the left, Lucretia tries to pull away from Sextus, the son of Tarquin the Proud; on the right is Lucretia's suicide after having been dishonored by Sextus; in the center, the culmination of the drama with Brutus showing Lucretia's body to the soldiers as he incites them to revolt. The architectural backdrops in some ways recall perspectives painted by Piero della Francesca.

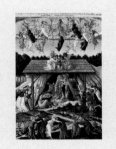

### ♦ THE MYSTIC NATIVITY (1501)

This is the most significant work of Botticelli's phase of "*Piagnone*" mysticism. Archaic in structure, the panel is connected with some passages from the *Book of Revelations* and is deliberately cryptic, as indicated by the Greek words across the top. On high is a circle of dancing angels, with Grace, Truth, and Justice on the roof of the hut and below, the reconciliation between angels and contemporary man through an embrace.

### ♦ EPISODES FROM THE LIFE OF ST ZENOBIUS (c. 1505)

This title refers to four panels with stories from the life of the bishop of Florence who lived between the fourth and fifth centuries. The first two panels are in the National Gallery in London, the third in the Metropolitan Museum of New York, and the fourth in the Gemäldegalerie in Dresden. They are Botticelli's last known work.

# TO KNOW MORE

The following pages contain: some documents useful for understanding different aspects of Botticelli's life and work; the fundamental stages in the life of the artist; technical data and the location of the principal works found in this volume; an essential bibliography

## DOCUMENTS AND TESTIMONIES

### As the biographer Vasari recounts

*Giorgio Vasari was born in 1511, one year after the death of Botticelli, thus the information he reports in his biography of the artist can no longer be considered first-hand. What is more, his viewpoint is colored by his lack of enthusiasm for an artist whom he suspected of being a "piagnone" (follower of Savonarola), something which he, a good courtier of the Medici, could not forgive. In fact, it was his opinion that this was the cause of the "great disorder" into which the artist fell and which led him to abandon painting.*

"At the same time with the elder Lorenzo de' Medici, the Magnificent, which was truly a golden age for men of intellect, there also flourished one Alessandro, called Sandro after our custom, and surnamed Di Botticello…
He made many works in the house of the Medici for the elder Lorenzo, particularly a Pallas on a device of great branches, which spouted forth fire: this he painted the size of life, as he did a St Sebastian. In S. Maria Maggiore in Florence, beside the Chapel of the Panciatichi, there is a very beautiful Pietà with little figures. For various houses throughout the city he painted round pictures, and many female nudes, of which there are still two at Castello, a villa of Duke Cosimo's; one representing the birth of Venus, with those Winds and Zephyrs that bring her to earth, with the Cupids; and likewise another Venus, whom the Graces are covering with flowers, as a symbol of spring; and all this he is seen to have expressed very gracefully…
In the house of the Pucci, likewise, he painted with little figures Boccaccio's tale of Nastagio degli Onesti in four square pictures of most charming and beautiful workmanship… It contains the Adoration of the Magi, and wonderful feeling is seen in the first old man, who, kissing the foot of Our Lord, and melting with tenderness, shows very clearly that he has achieved the end of his long journey. The figure of this King is an actual portrait of the elder Cosimo de' Medici, the most lifelike and most natural that is to be found of him in our own day…
It is not possible to describe the beauty that Sandro depicted in the heads that are therein seen, which are drawn in various attitudes, some in full face, some in profile, some in three-quarter face, others bending down, and others, again, in various manners; with different expressions for the young and the old, and with all the bizarre effects that reveal to us the perfection of his skill… Where *[in Florence]*, being a man of inquiring mind, he made a commentary on part of Dante, illustrated the Inferno and printed it…

He also printed many of the drawings that he had made, but in a bad manner, for the engraving was poorly done. The best of these that is to be seen by his hand is the Triumph of the Faith effected by Fra' Girolamo Savonarola of Ferrara, of whose sect he was so ardent a partisan that he was thereby induced to desert his painting, and, having no income to live on, fell into very great distress. For this reason, persisting in his attachment to that party, and becoming a Piagnone *[Mourner, or Weeper]* (as the members of the sect were then called), he abandoned his work; wherefore he ended in his old age by finding himself so poor, that, if Lorenzo de' Medici, for whom, besides many other things, he had done some work at the little hospital in the district of Volterra, had not succoured him the while that he lived, as did afterwards his friends who loved him for his talent, he would almost have died of hunger."

[Giorgio Vasari, *Lives of the Painters, Sculptors, and Architects*, Engl. trans. by G. de Vere, 1912, Everyman's Library edition, New York, 1996]

## The iconographical themes

*A large number of scholars and art historians have for a long time debated the meaning of* The Allegory of Spring *from a strictly thematic point of view. The discovery in archives of new documents concerning the Medici family and the development of new hypotheses transform the garden of Venus and the Graces into a forest of symbols to be interpreted each time in a different manner.*

"The iconographical research expounded in Aby Warburg's dissertation was the first to establish that the thematic content of the painting was based on a mixture of ancient and contemporary literary sources, all deriving from texts by Horace, Seneca, Lucretius, and Ovid. According to Warburg the painting represents, in the guise of the female figure set slightly back almost in the center of the picture, the goddess of Love in her kingdom… Read in this key, identification of the figure of Spring is problematic, given that in the classical genealogy of the gods this personage is not found and is mentioned only in some allegories. Subsequent interepretations refer back to an affirmation by Warburg himself, according to whom in the scene on the right, in front of Zephyrus and Chloris, appears not Spring covered with flowers, but Chloris again, changed into Flora. Ovid described Chloris as a wood nymph who was beautiful but immature and very clumsy, and who after being carried off by Zephyrus was changed into the flowered goddess of the Spring… Chloris madly and unsteadily lurches forward, while in her new guise as Flora, now significantly taller, she walks with a long stride, the erect and proud bride of Zephyrus, in the fullness of her regal presence. Following the medieval method of simultaneous representation, the two women represent the same person, first *ante* and then *post* metamorphosis."

[Horst Bredekamp, *Botticelli: la Primavera*, Franco Cosimo Panini, Modena, 1996]

## HIS LIFE IN BRIEF

**1445.** Alessandro Filipepi, known as Sandro Botticelli, was born in Florence, in the parish of Santa Maria Novella, the fourth and last child of Mariano, a tanner, and his wife Smeralda.

**1458.** Apprenticed to a goldsmith. The Filipepi family moved to a house owned by the Rucellai in Via della Vigna Nuova.

**1464.** The Filipepi family moved again to a house they had bought in Via Nuova. The Vespucci family, their neighbors, presented the boy to Filippo Lippi, who took him on as an apprentice in his shop in Prato, to learn painting.

**1467.** Returning to Florence from Prato, he entered the shop of Verrocchio.

**1469.** Mariano declared for the tax rolls that his son Sandro was a painter. At this point the artist had his own workshop.

**1470.** First public commission, to paint *Fortitude* for the Tribunale della Mercanzia.

**1475.** Painted Giuliano de' Medici's standard with *Pallas Triumphant* for a joust on horseback in Piazza Santa Croce.

**1478.** Frescoed above the door of the Customs House *The Hanged Men*, with the portraits of the conspirators Jacopo, Francesco, and Renato de' Pazzi and the archbishop Salviati. The painting was obliterated in 1494, after the flight of Piero de' Medici and the establishment of the Republic in Florence.

**1480.** Painted the fresco of *St Augustine in his Study* for the church of Ognissanti.

**1481.** Signed the contract for the frescoes in the Sistine Chapel and painted the first panel.

**1482.** Mariano Filipepi died in February. Finished the frescoes in the Sistine Chapel. In October was in Florence. Around this time painted *The Allegory of Spring*.

**1483.** Around this date executed some of his most beautiful paintings on classical themes: *The Birth of Venus, Venus and Mars, Pallas and the Centaur*. With his workshop assistants produced the four panels of *The Story of Nastagio degli Onesti*.

**1485.** Painted an altarpiece for the Bardi chapel in Santo Spirito representing a *Virgin and Child with St John the Baptist and St John the Evangelist*.

**1487.** Commissioned by the Magistrati di Camera to paint *The Virgin of the Pomegranate* for the Audience Chamber in Palazzo Vecchio.

**1489.** The Dominican friar Gerolamo Savonarola preached in San Marco, vehemently attacking luxury, corruption, and manifestations of paganism. Around this date Botticelli painted *The St Barnabas Altarpiece* (detail reproduced below).

**1492.** Death of Lorenzo the Magnificent.

**1493-95.** Death of his brother Giovanni. His brother Simone wrote the *Chronicle* of those years, revealing himself to be a fervent *"piagnone"* ["weeper"]. With his brothers Sandro bought vineyards and lands; painted *Calumny*.

**1498.** Savonarola burned at the stake.

**1500-05.** Botticelli's mysticism led him to create archaized pictures; painted new masterpieces.

**1510.** Died May 17; buried in Ognissanti with the rest of his family.

## WHERE TO SEE BOTTICELLI

*The following is a catalogue of the principal works by Botticelli conserved in public collections. The list of works follows the alphabetical order of the cities in which they are found. The data contain the following elements: title, dating, technique and support, size in centimeters, location.*

BERGAMO (ITALY)
**Stories of Virginia,**
c. 1500; tempera on panel, 165x86;
Accademia Carrara.

BERLIN-DAHLEM (GERMANY)
**The Virgin and Child with St John the Baptist and St John the Evangelist (The Bardi Altarpiece)**
1485; tempera on panel, 180x185;
Staatliche Museen Gemäldegalerie.

BOSTON (UNITED STATES)
**Stories of Lucretia,**
c. 1500; tempera on panel, 178x80;
Isabella Stewart Gardner Museum.

CAMBRIDGE (UNITED STATES)
**The Mystic Crucifixion,**
1500-1505; tempera on panel, 51x73;
Fogg Art Museum.

FLORENCE (ITALY)
**St Augustine in his Study,**
1480; fresco, 112x152;
Church of Ognissanti.

**The Adoration of the Magi,**
1475; tempera on panel, 134x111; Uffizi.

**Calumny,**
c. 1495; tempera on panel, 91x62; Uffizi.

**Fortitude,**
c. 1470; tempera on panel, 87x167: Uffizi.

**The Birth of Venus,**
1482-83; tempera on panel, 278.5x172.5; Uffizi.

**The Allegory of Spring,**
c. 1482; tempera on panel, 314x203; Uffizi.

**The Virgin and Child Surrounded by Angels,**
1470; tempera on panel, 85x120; Uffizi.

**The Madonna of the Magnificat,**
1482-83; tempera on panel, Ø 118; Uffizi.

**The Virgin of the Pomegranate,**
1487; tempera on panel, Ø 143.5; Uffizi.

**The St Barnabas Altarpiece,**
c. 1489; tempera on panel, 280x268; Uffizi.

**Pallas and the Centaur,**
1482-83; tempera on canvas, 148x207; Uffizi.

**Judith's Return to Bethulia,**
1470-72; tempera on panel, 24x31; Uffizi.

**Portrait of a Man holding the Medal of Cosimo the Elder,**
1474; tempera on panel, 44x57.5; Uffizi.

**St Augustine in his Study,**
c. 1495; tempera on panel, 27x41; Uffizi.

**The Discovery of the Body of Holofernes,**
1470-72; tempera on panel, 25x31; Uffizi.

GRANADA (SPAIN)
**Christ praying in the Garden of Gethsemane,**
1500-04; tempera on panel, 35x53; Capilla de los Reyes.

LONDON (GREAT BRITAIN)
**The Mystic Nativity,**
c. 1501; tempera on canvas, 75x108.5; National Gallery.

**Episodes from the Life of St Zenobius: the Three Miracles,**
c. 1505; tempera on panel, 75x108.5; National Gallery.

**Portrait of a Young Man,**
c. 1501; tempera on panel, 28.2x37.5; National Gallery.

**Venus and Mars,**
1483; tempera on panel, 173.5x69; National Gallery.

MADRID (SPAIN)
**The Story of Nastagio degli Onesti,**
(I, II, III panel)
1483; tempera on panel, 138x82; Prado.

MILAN
**Lamentation over the Dead Christ,**
c. 1495: tempera on panel, 71x107; Museo Poldi Pezzoli.

**The Virgin of the Book,**
1480-83; tempera on panel, 39.5x58; Museo Poldi Pezzoli.

**The Virgin of the Pavilion,**
c. 1493; tempera on panel, Ø 65; Pinacoteca Ambrosiana.

MUNICH (GERMANY)
**Lamentation over the Dead Christ,**
1489-92; oil on canvas, 207x110;
Alte Pinakothek.

NAPLES (ITALY)
**Virgin and Child with Angels,**
1468-69; tempera on panel, 71x100; Museo di Capodimonte.

ROME (ITALY) – PALAZZI VATICANI, SISTINE CHAPEL
**The Trials of Christ,**
1481-82; fresco, 555x345.5.

**The Trials of Moses,**
1481-82; fresco, 558x348.5.

**The Punishment of the Rebels,**
1481-82; fresco, 570x348.5.

WASHINGTON (UNITED STATES)
**The Adoration of the Magi,**
1481-82; tempera on panel, 104.2x70.2;
National Gallery of Art.

**Portrait of Giuliano de' Medici,**
1478; tempera on panel, 52.5x76; National Gallery of Art.

## BIBLIOGRAPHY

The bibliography on Botticelli is extremely vast. Here are some suggested sources for orientation and information on the artist, and a recent update of the bibliography. For an extensive listing of Botticelli studies, see the bibliography under the entry for Botticelli, prepared by R. Salvini, in *Enciclopedia universale dell'arte*, II, 1959.

**1550** G. Vasari, *Lives of the Painters, Sculptors, and Architects,* (English translation), New York, 1996.

**1908** P. Horne, *Alessandro Filipepi commonly called Sandro Botticelli, Painter of Florence*, London

**1925** A. Venturi, *Botticelli*, Rome

**1938** J. Mesnil, *Botticelli*, Paris

**1957** G.C. Argan, *Botticelli*, Geneva-Paris-New York

**1967** G. Mandel, *L'opera completa del Botticelli*, Milan

**1980** H. Horne, *Botticelli. A Painter of Florence*, Princeton (N.J.)

**1986** U. Baldini, *La Primavera di Botticelli. Storia di un quadro e di un restauro*, Milan

**1987** E. Gombrich, *Immagini simboliche. Studi sull'arte del Rinascimento*, Turin

**1989** R. Lightbown, *Sandro Botticelli*, Milan

N. Pons, *Botticelli. Catalogo completo*, Milan

G. C. Argan, *Botticelli*, Geneva-Rome

**1990** C. Caneva, *Botticelli. Catalogo completo*, Florence

G. Cornini, *Botticelli*, Florence

**1992** M. Albertario, *Botticelli*, Milan

**1996** H. Bredekamp, *Botticelli. La Primavera*, Modena

**1997** E. Capretti, *Botticelli*, Florence

# ONE HUNDRED PAINTINGS:

## every one a masterpiece

## ——— Also available: ———

*Raphael, Dali, Manet, Rubens,
Leonardo, Rembrandt, Van Gogh,
Kandinsky, Renoir, Chagall*

**Vermeer**
*The Astronomer*

**Titian**
*Sacred and Profane Love*

**Klimt**
*Judith I*

**Matisse**
*La Danse*

**Munch**
*The Scream*

**Watteau**
*The Embarkment for Cythera*

**Botticelli**
*Allegory of Spring*

**Cézanne**
*Mont Sainte Victoire*

**Pontormo**
*The Deposition*

**Toulouse-Lautrec**
*At the Moulin Rouge*

## ——— Coming next in the series: ———

*Magritte, Modigliani, Schiele,
Poussin, Fussli, Bocklin, Degas,
Bosch, Arcimboldi, Redon*

CONCORD FREE
CONCORD
MA
PUBLIC LIBRARY

DEC 1 8 2000